769.715 SMA

D0945118

PRICE: $25.00 (3798/anf)

NOV - - 2021

n

Materiality and Perception in Contemporary Atlantic Art

Materiality and Perception
in Contemporary Atlantic Art

TOM SMART

BEAVERBROOK ART GALLERY

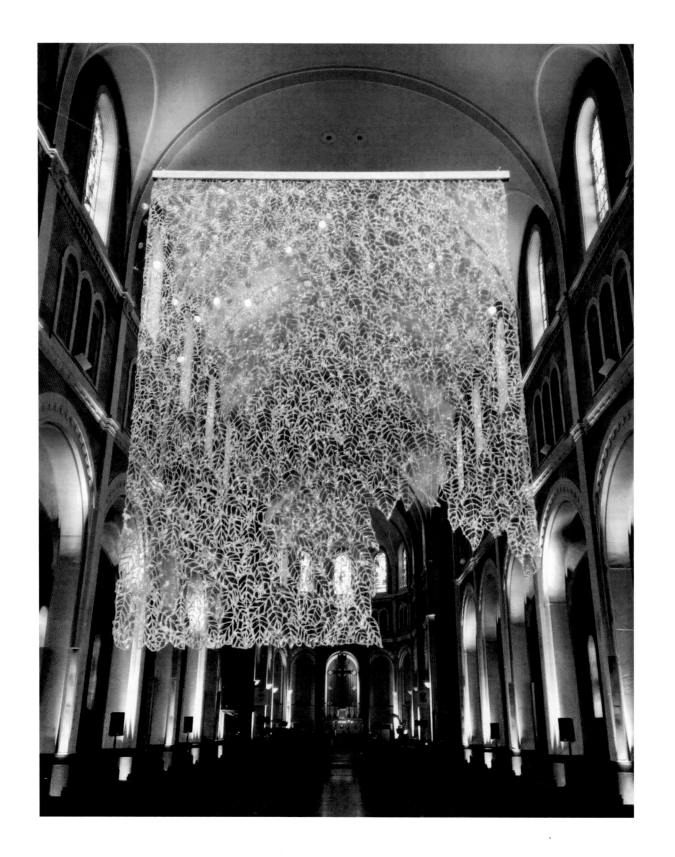

Foreword

ANN McCAIN EVANS

Arts and crafts were always an important part of my mother's life. She earned a certificate in applied arts from Mount Allison University in 1951 and continued her passion for art with classes at Sotheby's Institute of Art in London, England, and Sunbury Shores Arts and Nature Centre in St. Andrews, New Brunswick.

It has now been over thirty years since my mother organized her first exhibition at the Beaverbrook Art Gallery. Her focus in the first three shows (1987, 1989, and 1991) was to highlight the work of artists in New Brunswick. In 1994 that focus broadened to include artists from all the Atlantic provinces.

The installation of the Marion McCain Exhibition of Atlantic Art, curated by Tom Smart, reflects my mother's abiding interest in how art and decorative arts are expressive agents for the individuals creating them. They are also ways for viewers to explore both how objects themselves and the materials from which they are made change the way we see ourselves, our communities, and the world at large.

On behalf of my siblings, Mark, Laura, and Gillian, I would like to express my gratitude to Tom Smart and his staff at the Beaverbrook Art Gallery for all their work on this exhibition. This gratitude also extends to all the artists in Atlantic Canada. Your art was an inspiration to our mother and is a gift to all of us.

opposite:
Vicky Lentz (New Brunswick)
Where the Trees Meet the Stars, 2018, in situ

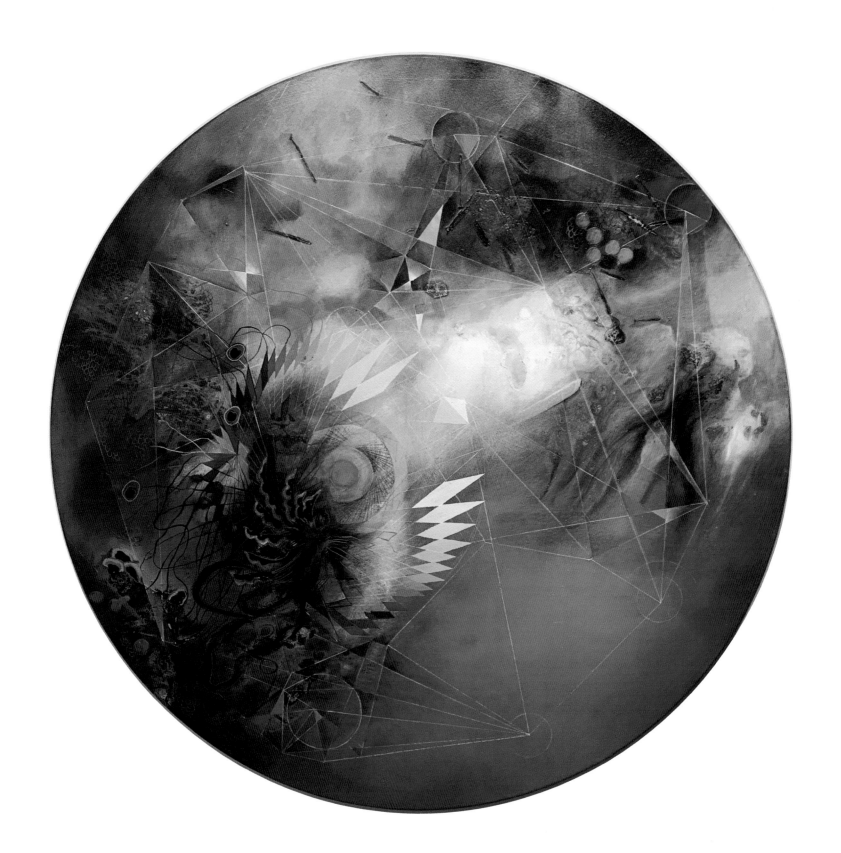

Introduction

In addition to being an arts patron, benefactor, and advocate for art and artists (particularly from New Brunswick and Atlantic Canada), Marion McCain was an artist. As a student at Mount Allison University, she studied visual art and art history. This experience formed the foundation of a lifelong appreciation for the visual arts and artistic creation.

When my research for this exhibition began, I had the opportunity to look closely at two works of art Marion McCain made as a university student. One was a fine, intricately crafted ring, and the other was a decorative piece of furniture that included a delicate pattern incised in leather.

What struck me initially was that these objects reflected a creative sensibility that found expressive agents in different materials. In shaping and using these materials, Marion McCain was attuned to exploring their properties and potentials as artistic media. Materiality was an important artistic stimulus for McCain; things and matter inspired her, propelling her to follow the paths that opened up as she formed and combined materials when creating new meaning through art.

What soon became apparent to me was that, by combining different materials, she opened up new ways for me to view art and the world around me. The objects she created, while having a purpose as jewellery and furniture, were not limited to their functionality. The unique juxtapositions of form, matter, and media changed my perceptions.

opposite:
Deanna Musgrave (New Brunswick)
A Conversation with Emma Kunz, 2019

Through viewing Marion McCain's creative expression, I came away with an impression that the interaction of materials provides us with an expansive visual poetry, containing new ways to think about the world we live in. McCain reminded me that art has the capacity to arrange the ways we view the world. An exhibition like this exists in a symbiotic relationship with the most important questions in society; the act of viewing provides a lens to explore these issues, while at the same time being informed by these very same issues.

My experience of Marion McCain's art informs this exhibition. The works have been chosen from among the many submissions we received and augmented by selections I have made from studios. My purpose, prompted by her example, is to explore how material conversations affect our perceptions, and how we might manage to discover coherence in an arrangement of artistic objects in an art gallery.

Materiality and Perception in Contemporary Atlantic Art

This exhibition, a collection of works by many different artists, explores the paradox that an assemblage of objects in a room places before the curious, engaged viewer. Do we actually organize our perceptions by taking in discrete objects and experiences and somehow blend them to form a unifying principle that gives the feeling of continuity? The artists in this exhibition have been selected because of the unique materiality of their works. The art expresses meaning by and through the materials it is made from as much as (if not more than) the subjects or symbolism represented, forcing us to re-examine both the objects themselves and our perceptions.

The artists in *Materiality and Perception in Contemporary Atlantic Art* have also all been selected on the basis of how their works individually — and as a group — embody the idea that consciousness is a flow and flux of individuated, singular sensations. Each piece means something on its own, and as a curated group, they invite us to discover meaning through our interactions with them. The very fact of their presence in the same space at the same time establishes an arena for coherence to become evident. What devices or forms have the capacity to give this unity to apparently disconnected objects? The question points to a paradox seeking resolution. As much as we view each work as an individual object, new meanings arise when we consider the collection of discrete objects holistically in a single exhibition.

This concept is no better expressed than in the art of Kim and Wayne Brooks, Wolastoqiyik artists who live beside the Wolastoq/Saint John River. Their work

10 **Carrie Allison** (Cree-Métis/Nova Scotia)
Beaded Botanical 1 (allium tricoccum), 2018

expresses the recognition that the land the river nourishes, and on which the Beaverbrook Art Gallery is situated, has been the home of generations of peoples of several First Nations and colonial nations who found in the beauty and bounty of the land a place to call home.

The Brookses' art draws on the forms and functions of traditional modes (p. 59). These have been reinterpreted to reflect not only historical methods, but also contemporary concerns about the collision and interaction of cultures on this part of the eastern side of Turtle Island (North America). In the wake of Canada's Truth and Reconciliation Commission, the Brookses' art provides meaningful objects that connect us to the land, while also pointing out that the history of western European colonization has not yet been balanced with the acceptance that this history is one of occupation and usurpation that needs to be addressed, reconciled, and made whole.

This also is the purpose of Carrie Allison's multidimensional, symbolic forms (p. 10). As an Indigenous, mixed race artist, born and raised in unceded and unsurrendered Coast Salish Territory, her artistic practice responds to her maternal Cree and Métis ancestry. Allison's dense, allusive works of art interpret intergenerational cultural loss. Through her practice she reclaims, remembers, recreates, and celebrates her ancestry emblematized in symbolic objects that are informed by her examination of Indigenous, mixed-race, antiracist, feminist, and environmental theorists.

Wolastoqiyik ("people of the beautiful, bountiful river") artist Emma Hassencahl-Perley engages with similar concerns. Her wide-ranging use of materials, forms, and creative inquiries examines the theme of "legislative identity." She probes the nature of the truth about the shared histories between Indigenous Nations and the Settler, and her identity as a Wolastoqey woman. *Creation Story II* (p. 68) is a symbolic depiction of how personal identity is an element of communal identity, as well as representing a connection to the Earth. Her emblematic iconography references four medicines and the sacred fires that connote the creation story of Turtle Island, and the story

of the artist's matrilineal heritage through the lives of her great-grandmother and her aunt. The painting illuminates the idea that the sense of self is a complex web of interconnections with the present, past, and spirit realm. Her work evokes pride in the personal and imbues it with a political charge, underlining the inevitability of identities being politicized—especially in First Nations relationships to Settler cultures.

Ann Manuel (p. 13) evokes a sense of place through a series of works that regard the land as a sanctuary that may not have been properly stewarded in recent generations. The inherent symbolism of her complex sculptural objects asks the viewer to explore how a relationship to land and history is always informed by a conscious awareness of one's responsibility as a citizen of place. For Manuel, place references ideas of family, home, and of community in a historical continuum in which the requirement for nurturing resources and sustaining the land is a sacred responsibility. Her art comprises subtle object-based interventions, in particular landscapes and places, many of which are highly venerated. Manuel's art is a metaphoric language of home, whose grammar is expressed in the small objects that congregate in nature. Nests, seedpods, branches, and roots all spell out in their own ways the nature of sanctuaries and how they sustain communities.

If Manuel's work gives us a visual poetry of brevity, of small things symbolizing concepts of proper stewardship of the land for future generations, Yalda Bozorg (p. 70) looks at the idea of landscape as a site of severe trauma. In her work, the catastrophe of war as it destroys communities, families, and individual psyches is presented as time-based process pieces fabricated in porcelain, which ask for prolonged bservation and mediation. Bozorg's severe, accusatory art has a redemptive quality in its complex interactions of colour, texture, and formal structure, giving ample space for a safe exploration of the nature of trauma and how matter—kiln-fired and glazed clay— can map, explore and understand minds that have been prone to depression and bodies that have been deprived of a forum for talking about their afflictions.

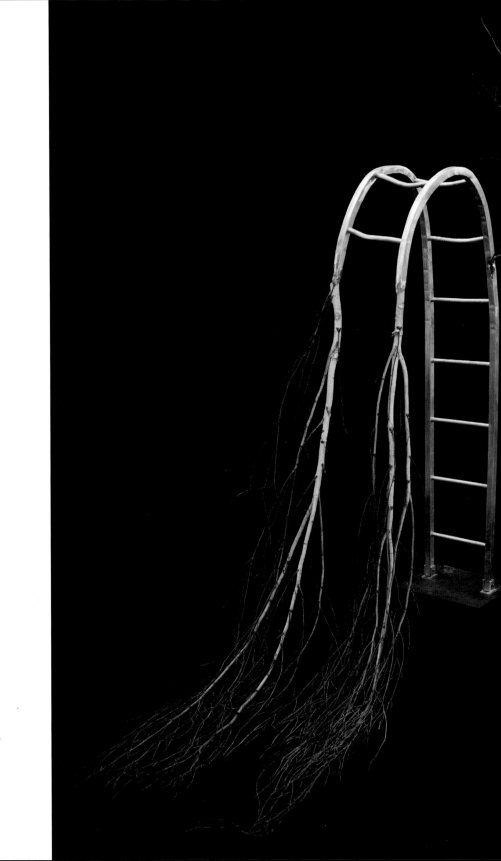

Ann Manuel (New Brunswick)

Weed Species, 2014

Human frailty, a theme that informs Bozorg's ceramic art, also permeates the work of Dawn MacNutt (p. 63). By combining several object-making traditions from what is easily categorized as "fine art" and "craft," MacNutt constructs visual symbols of human emotions, particularly how feelings and moods are translated through postures and gestures. Using materials such as willow branches, wire, and cast bronze in woven constructions, MacNutt's art gives the impression of the body moving through space. She often examines the transitory nature of materials by casting objects originally made from combustible matter, in bronze. Traces of the prior material remain, but the frailty of the original material is made permanent through forge, fire and molten metals. MacNutt imbues matter with presences that appear animate, dynamic, living, despite the fact that her sculptural objects are innately still.

In a manner similar to MacNutt, Laura Roy (p. 52) works with a variety of media and modes to interpret what lies below the body's carapace. By juxtaposing embroidery and needlework with paper, textile, fabric, paper, and many other materials, Roy creates a multilayered depiction of body and mind. *What the Mirror Doesn't See, Below the Surface (Skin), Self Portrait in Thread* confronts the symbolic representation of the bodily functions of digestion, the pulmonary system, and the nervous system as they affect the artist in perilous ways. Roy's are complex ideations of body and subject, and traces of physical, emotional, and social trauma on both the individual (frequently the artist) and the body politic.

Just as Laura Roy's art lays bare the inner workings of body and mind, the compositions of Sarah Petite and Luc A. Charette provide viewers with a satisfying insight into the artists' creative approach. Petite's abstract painting comes from a creative encounter with media and support, embodying a profoundly human expression of mood, motion, and visual energy (p. 32).

Charette's painterly method is deliberate and intuitive; he sets down shape and form in ways that are both automatic and purposeful (p. 16). As you view the

complicated surfaces and depths that the illusory overlays establish, you are drawn not just into the painting itself but to an artistic consciousness that seeks to present itself boldly and emphatically while immersing you in a dialogue with its artist subject. There is nothing one way about his painting. Its bold purpose is declarative, demanding that the viewer respond to the signs and symbols set down in graphic cadences. The signs spell out a language of an entirely different order that grabs the unconscious and alters perceptions.

An analogous impulse informs Jared Betts's art, which incorporates a creative strategy of dream visioning. His multi-modal paintings—formalist, abstract, colour-saturated, gestural compositions that combine graphic mark-making with the inscrutability of colour fields—inhabit the imaginative space where consciousness dissolves and expresses its symbolic iconography in dreams (p. 45). Through a dense visual vocabulary, Betts's painting conjures immersive sensory experiences that enfold not only the creator of the statement but also the viewers into a cerebral environment. His project, while materially based and referencing contemporary painterly approaches, seeks to propel the perceptive viewer into the realms of metaphysics—all the better to confront the ways in which mind and body come together, detach, and then re-combine in new, adaptive configurations.

A similar vision informs Deanna Musgrave's large-scale paintings (p. 6). Her immersive compositions envelop the viewer and activate the gallery spaces in which her paintings are exhibited. Musgrave invites viewers to examine how identities are formed and evolve as we gain more experiences. Her art is almost like a form of visual music where cadences and harmonies, discordances and lyrical passages all serve as visual simulacra of what it means to be human.

16 **Luc A. Charette** (New Brunswick)
Abstraction 04:112017, 2017

[o]

It seems counter-intuitive to think that we process what is before us as one disconnected thing after another, in search of an organizing principle. For some, such a principle might be generated internally through a process of self-realization. For others, an overarching external hand or guiding ethos has the power and capacity to make sense of the pieces that give us ownership of a personal narrative and a context in which our story is played out.

What then can we make of the experience of moving through an exhibition of art in which one object follows another in a random or predetermined pattern? The experience is chopped up into chunks, bits and pieces that when collected are meant to blur together in the way a series of still frames on a filmstrip dissolve as discrete pictures into a continuous flow that becomes a movie.

This is the effect I get from the relief collages of Brian Mackinnon (p. 69). The quality of his densely packed compositions of brightly coloured toys is more of a cacophonous array of shapes and forms that, when accumulated into a single frame, give off a sense of a coagulated yet coherent consciousness. His relief sculptures are emblems of childhood memories and trauma fixed in a static, closely compacted ensemble that, while having an indisputable unity, threatens to disintegrate into chaos if the delicate property of balance and integrity is violated. While his work comprises a curiously whimsical poetry emanating from the juxtaposition of colours and forms, the apparent lightheartedness is betrayed by a colourful and form-based hysteria.

The experience of individual artworks flowing into one another to create a broader meaning is similar to the sensation I receive from Brigitte Clavette's recent work exploring her preoccupation with the theme of abundance (p. 18). In her art, objects of very different shapes, textures, and forms flow one into the other. Yet the manipulation of materials and discordant interaction of symbol and allusion provide an overarching coherence. Clavette's subtly complicated objects and vessels are made

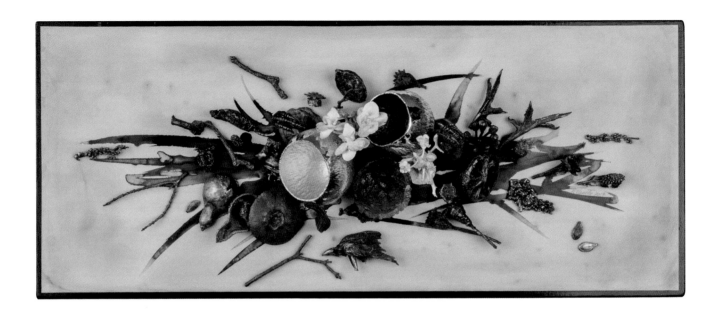

by testing and pushing the limits of her media. She attacks the silver with hammer blows, pushing the strength of substance to the breaking point. Clavette's approach is intuitive and non-linear; she gives herself over to accidents cast up by method, altering her ideas according to the nature of the conversation between mind and metal.

Clavette's work in this exhibition expands on her recent series of metallic interpretations of "skins," redeeming elements of discarded foodstuffs by casting them in silver. Found objects and items retrieved from the fate of compostable waste, the foodstuffs are reconceived as allusive objects whose original nature, while hinted at, is only tangentially acknowledged. By casting food as silver integuments and then arranging them around an empty vessel, Clavette critiques the notion of the beautifully decorative silver utilitarian object as a centerpiece that attracts gourmands, reminding us of the absurdity of chasing and hammering a precious metal. Clavette's art resides in the languages of delicacy and illogic, framed through the interaction of taste and sight.

Brigitte Clavette (New Brunswick)
Wasted—1861 Grams Sterling Silver, 2017

[o]

Viewing these pieces, another question comes to mind. What is the impetus to make
a continuous narrative from discrete pieces? How do we make sense of discontinuity
as a fundamental characteristic, not only of perception, but also of the human
condition? This is one of the many ideas embodied in the purely visual poetry of
Freeman Patterson's photographic art and his piece *Monet Willow/Un saule de Monet*
(p. 40-41). Evident in this composition are Patterson's interests in gardening as an
expressive form, and his intense, career-long examination of how photography
can find signatures of eternity in precisely calibrated and chosen moments.

 A similar feeling of eternity and transcendence occurs in me when I view the work
of Alan Syliboy, Ned Bear, and Charles Gaffney. Syliboy's *Brain with Headdress* (p. 44)
combines contemporary neuroscience with traditional Indigenous iconographies
informing headdresses, blending the mind with nature, land, and history. Ned Bear's
and Charles Gaffney's masks (p. 22 and p. 21) convey the idea of movement in their
very stillness. They portray entire dimensions of consciousness, mood and emotion
in the sculpture of a face. In the immovable, still regard of their sculpted expressions,
Bear and Gaffney carry the attentive viewer through pre-colonial and post-colonial
interpretations of humanity's relationship to land and spiritual essence. They
transport viewers through vast dimensions of being and time, linking them to what
is eternal and true. These masks tell me that if experience were just a series of
discrete, unconnected parts, the victims would be memory and knowledge. All that
could be known would be the present; everything else would have vanished the
second it is perceived.

 Raven Davis's *Child's Play for Them, Murder for Us* (p. 23) is a critique of a dominant
Canadian national narrative that erases the genocidal histories of Indigenous people
when confronted by European Settler culture. Davis's work exposes the hypocrisy of
such historical myths and demands that generations-old injustices be represented

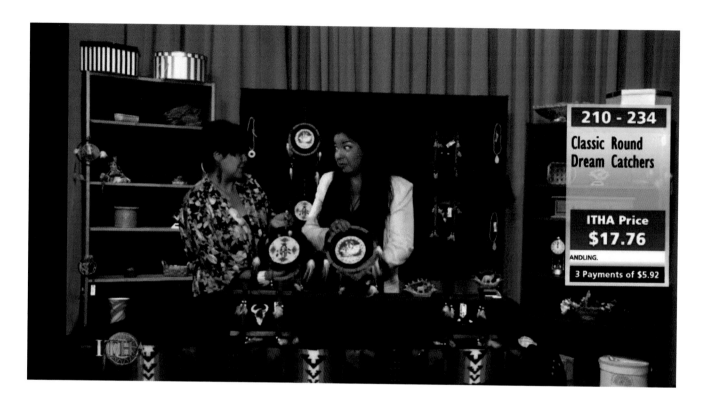

210 - 234
Classic Round
Dream Catchers

ITHA Price
$17.76

ANDLING.

3 Payments of $5.92

and confronted before it is even remotely possible to speak of reconciliation. *Child's Play for Them, Murder for Us* exposes the murderous and assimilationist policies that erased Indigenous presence in a falsely historical and so-called beneficent narrative of nation building. Rather than celebrating a national sesquicentennial in 2017, Davis' work de-celebrates the anniversary by pointing to past atrocities and present injustices against Indigenous people. Davis tells us that "there is nothing much to be celebrated, and much more work to be done."

Ursula Johnson's art also comments on the realities of preserving Indigenous cultures and objects in contemporary society. *ITHA Shopping Network* (above), for example, comments on the commodification of Indigenous art forms, which have ostensibly sacred purposes. She voices an ironic, critical comment on ways these sacred icons are reduced to mere retail merchandise whose original purposes have been lost in the contextless void of a televised shopping network.

above:
Ursula Johnson (Mi'kmaq/ Nova Scotia)
ITHA Shopping Network, 2017

opposite:
Charles Gaffney (Wolastoqiyik/ New Brunswick)
Qsihkawk, 2018

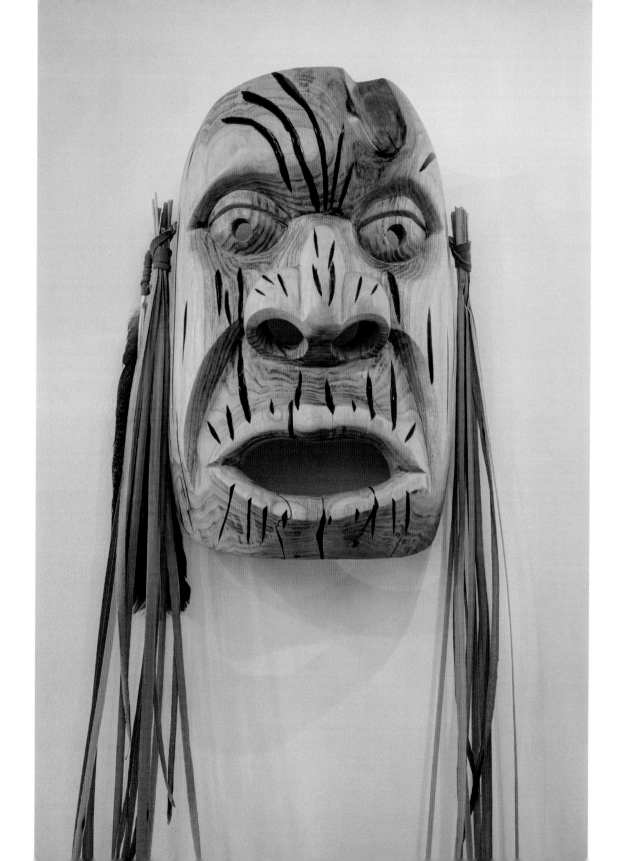

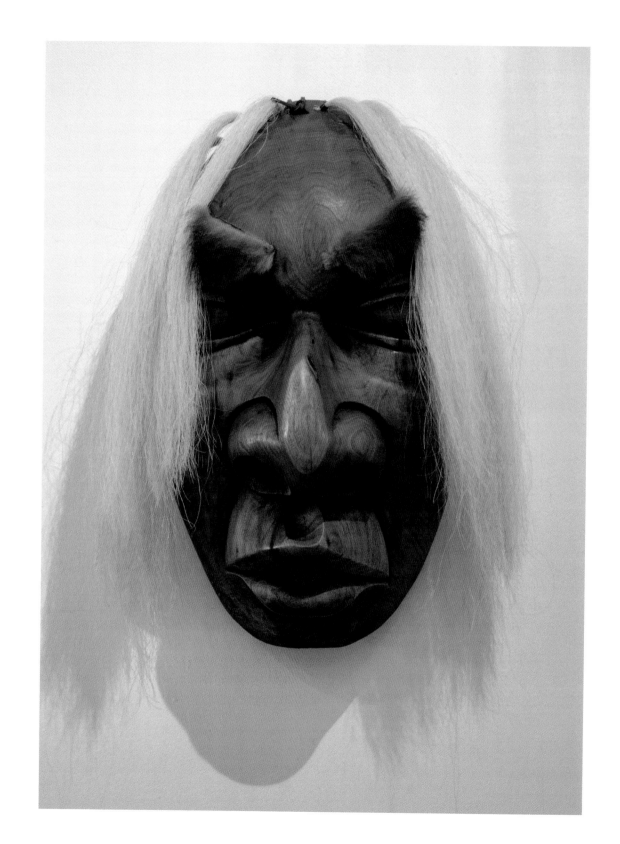

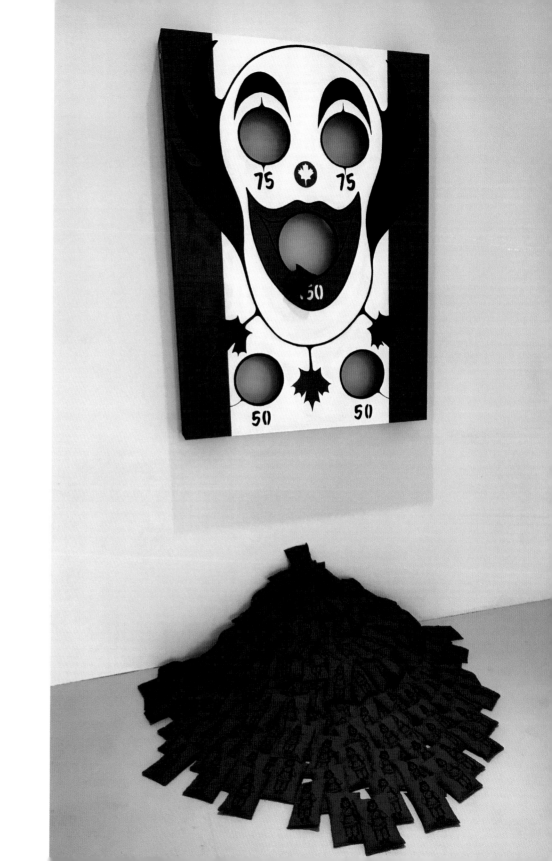

opposite:
Edward "Ned" Bear (Cree-Wolastoqiyik/
New Brunswick)
Napeh Kaso yinew Kiskeyitan, 2018

right:
Raven Davis (Anishinaabe/Nova Scotia)
Child's Play for Them, Murder for Us, 2017

[o]

Questions of perception and realism feature strongly in David McKay's art. His tempera paintings on shaped panels set up an expectation of uncanniness in their apparent realism, yet McKay dashes these expectations by encouraging a form of inquisition into the nature of realism and the filament-fine separation between the present tense and the pluperfect essence of home. His subjects, as seen in *Swaying With the Wind* (p. 42), while based on observation, might well be traces of a vague dream that exchanges fact-based description for felt observation.

Reclamation is also the embedded theme in William Forrestall's sculpted automobile-like objects (pp. 66-67). They riff off the forms and functions of the go-cart and early twentieth-century single-stroke-powered delivery vehicles. But their relationship to these historical antecedents is quickly dispelled by the disparate array of things used to construct them. These are entirely imagined conveyances that nevertheless speak to a modality in which the mind and imagination have energies to animate these skeletal, self- or gravity-propelled vehicles along tracks in the imagination or in a transformed, so-called real world.

The principle of reality transforming into pure essence is evident in Margot Metcalfe's mystical photographs (p. 74). In a closely observed and interpreted microcosm, Metcalfe creates metaphors of divinity. Light, as it illuminates form, is the animating agent that leads her to find moments of transubstantiation in the world.

[○]

An exhibition's parts might be intended to aggregate into a comprehensive statement about a historical or contemporary idea or theme. An exhibition of this sort might serve to express a polemic against a contemporary force or social policy that is outside of the institutional walls of the exhibition gallery. Other structuring principles for exhibitions have them initiating or taking part in debates. They comprise one or a series of dialectical propositions that encourage (often demand) the viewer to engage with the ideas as they are formulated through objects or phenomena that are placed in the viewing spaces.

How do we perceive what is before us? Is it a natural function of human perception to find fluidity of ideas in the interaction of one thing and then another? Or rather, is continuous motion a more descriptive metaphor to frame perception? Certainly, the latter model acknowledges the greater complexity of the perceptual experience as a multitude, perhaps a countless series, of interactions with stimuli which, when drawn together in a holistic form, constitutes the perception of an event, place, experience, or context. Perception is not simply a construction built from calculation. It is a quality of experience that informs awareness and enhances consciousness. Perception prompts transformations in ways that are hardly understandable, when the accumulation of stimulations turns into a flowing subjective experience. These probing questions into the nature of perception and between subject and object inform Jennifer Pazienza's creative practice exemplified in her lyrical painting *Sorella I* (p. 49).

In a similar manner, but in a different mode and medium, Jennifer Stead focuses on how perception and observation interact with nature and place (p. 26). Stead also draws from her life's experiences, expressed symbolically in the formal vocabulary of landscape representation. Her drawings trace authentic experience where fact, feeling, and personal vision all coalesce into a narrative that extends from the personal and becomes universal.

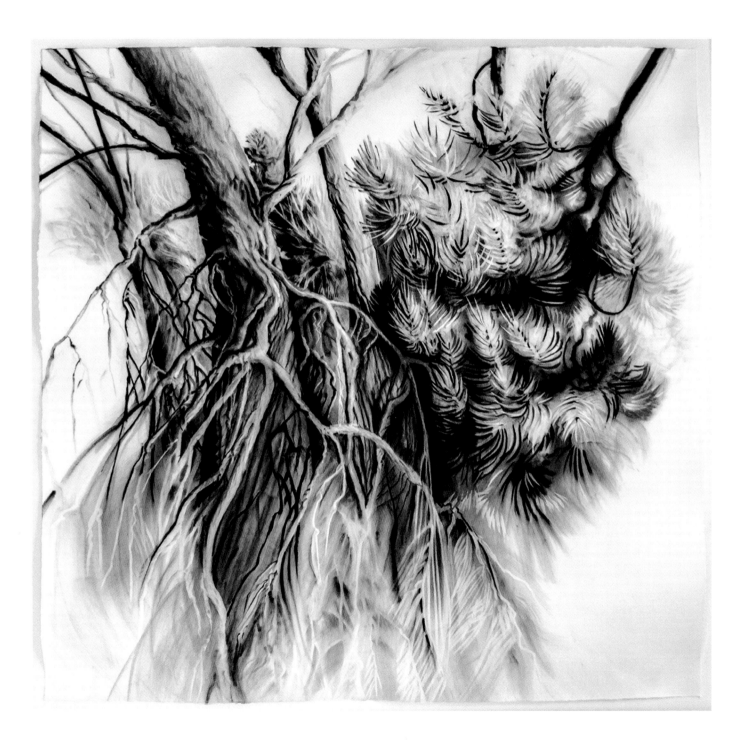

26 **Jennifer Stead** (New Brunswick)
A Forest, 2015

Like Stead, Janice Wright Cheney probes modern ideas about the separation of the cultural and natural worlds (pp. 54-55). Her art expresses this distinction via the incursions of various creatures from the natural into the human realm. By interpreting these transgressions as art, Wright Cheney renders nature into culture, underlining the thin separation of humanity from nature and its creatures. The work causes us to reflect on the nature of nature, and how the animals that once roamed in the woodlands of eastern North America are being depleted to such an extent that the creatures often exist only in our minds and imaginations. This is true of the cougar, which Wright Cheney seeks to "conjure" through her multimodal work. The cougar is an enigmatic species that, while sighted infrequently in the Maritimes, has been endowed with a kind of shadow identity. The cougar populates the woodlands like a ghost, a phantom, a projection from an individual or collective unconscious. Wright Cheney's site-specific interventions and videos involving a cougar-like silhouette situated in an actual woodland setting are intended to set up an uncanny dialogue—a rewilding—with a perceptual moment in which we question what has been incarnated before our eyes. Is it real or imagined? Is it a figment of memory, history, myth, all projected onto the familiar? Wright Cheney leaves the questions unanswered, preferring to cast the viewer adrift in forests of the past — untamed, dense wildernesses and places of magic and danger with few bearings except those that are deeply embedded in the unconscious.

Francine Francis's *Mimikej—Monarch Butterfly—Papillon Monarque* (p. 43) is a highly allusive metaphor expressed in the elegantly simple language of watercolour painting. It points to a deep western tradition of taxonomic representation familiar to museum curating. Yet, in Francis's hands, the device of the monarch butterfly is laden with a message—a warning that the human species is depleting animal, fish, and bird life in a grandly tragic extinction that will deprive us of the majestic delicacy of such a creation as this butterfly, and of innumerable other species as habitat is destroyed.

Gerald Beaulieu's *When the Rubber Meets the Road* (pp. 46, 47) speaks to the same issue, but in a way that reminds us how humanity affects the ecosystems we share with many creatures. The open road is a dangerous place where accidents happen and carnage of species is the consequence. His images reclaim discarded detritus—in this case used tires—into sculpted carrion-consuming corvids.

[○]

"Flow" and "flux" are words that have the capacity to present in understandable language what happens when we are affected by something outside ourselves, process the information, turn it into a coherent experience, and have that experience become an element of who we are as humans. The experience of an art exhibition gives a faint hint at how the perceptual process might work, albeit as a simplified analogy.

This perceptual model informs the work of Vicky Lentz, particularly her multi-media screen *Where the trees meet the stars* (p. 4). This piece, as with all Lentz's work, developed from a deeply personal connection she has to the environment, a sensibility formed as a child growing up in an isolated family farm in the Ottawa Valley. Joyous youthful memories of living in this landscape remain with her to this day. Her sensitivity to the subtleties of seasonal changes makes her receptive to moments of grace that deepen her connection to the natural world and nourish her art. As humans continue to concentrate in large, densely populated urban areas, Lentz states that it will become increasingly important that we preserve and honour the rewards of a rural life lived in a direct, sensitive dialogue with nature.

Stephen Hutchings's large-format, immersive landscape paintings, such as *Now and Then* (pp. 38-39), oscillate between objective and subjective perceptions; they describe the land in these two modes. They allow for an exploration of a richly metaphoric interpretation of identity, his and ours, that embodies mystery, revelation, the particular, and the infinite all at the same moment. His paintings tell us that we

have the capacity to shape our perceptions, direct the encounter in which we are both director and subject, poet and poem.

Beth Biggs's art points to the idea of jewellery as bodily adornment, of materials and forms as decorative and allusive devices that speak of the body as a complex site on which social, gender-based, political, and conceptual meanings all collide and intersect (right). Her art symbolizes the complicated relationships established by meaning-laden objects presented in relationship to the body, particularly the female body. As an artist examining feminist issues, Biggs compels her viewers to probe the connection between femininity and adornment, between style and presence that have contemporary allures and historical antecedents.

Katie Augustine's work displays a similarly complex and personal conversation with media and form (p. 31). Augustine's woven vessels incorporate traditional basket making techniques and materials, reinterpreted in novel ways while still pointing to the past. Rather than exemplars of functional baskets, Augustine's sculptural objects are metaphoric containers into which ancestral tradition can be contained, examined, and become a source of strength with which to confront the present.

Alexandra McCurdy also plays with our expectations of particular objects and their uses. Her art asks the deceptively simple question: what is inside the box? (p. 30) Her series of boxes, merging the woven materials of textiles with clay, and the different elements of surface textures and forms, all simulate the effects of interlaced fabrics in porcelain. Her art evokes everything from the black boxes of aircrafts to the porcupine quill container that alludes to traditional Mi'kmaq and women's textiles. McCurdy's intention is to challenge viewers' expectations and awaken curiosity, causing us to look ever more closely at form and to develop a very different element of perceptual recognition. Her goal is to render her boxes as potent metaphors for the place and role of women in the production of ceramics. *Black Box* is meant to be mysterious in its exact allusion and in its ultimate function.

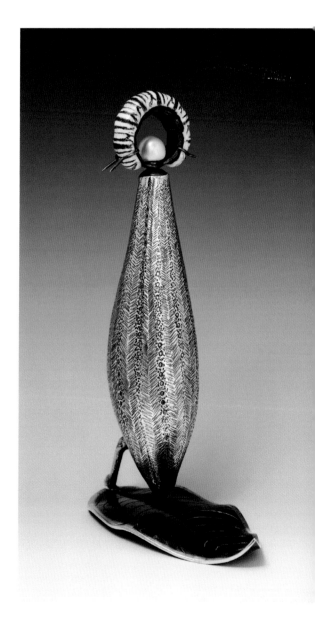

Beth M. Biggs (New Brunswick)
Host(ess) Monarch, 2008

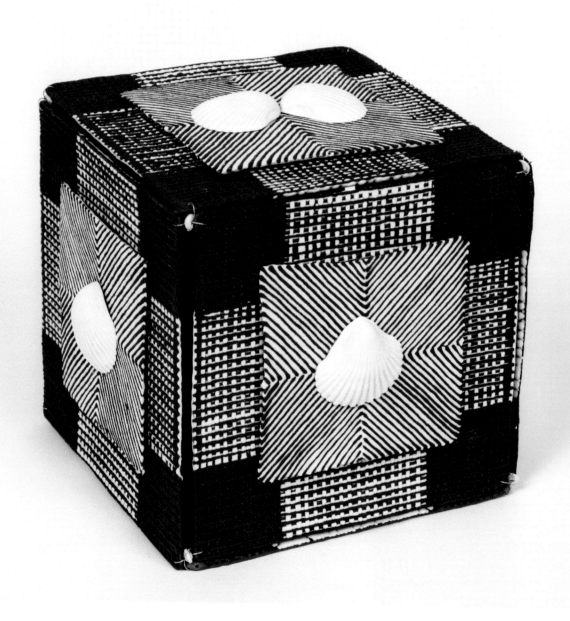

30 **Alexandra McCurdy** (Nova Scotia)
Black Box with Shells, 2018

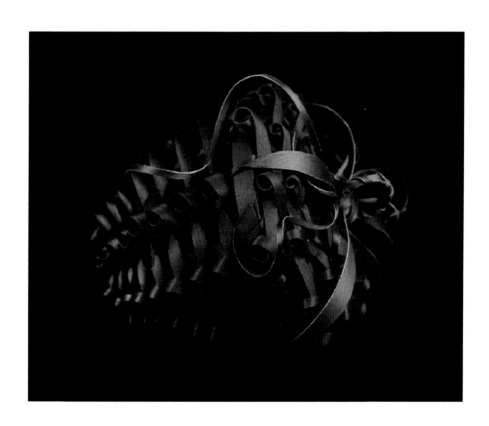

31 **Katie Augustine** (Wolastoqiyik/New Brunswick)
Psihqiminsok (*strawberries*) (detail), 2019

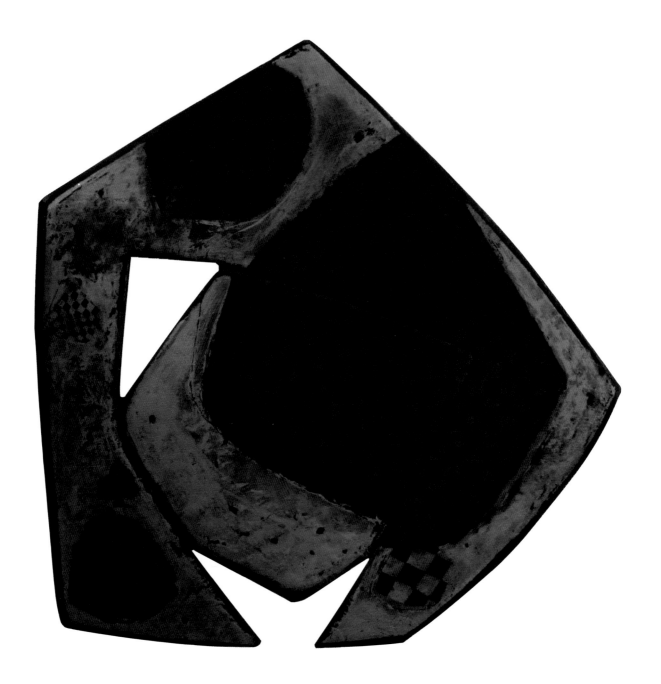

32 **Sarah Petite** (New Brunswick)
Cosmo, 2018

Themes of history in the present and ancestors among the living run through many of the works in this exhibition, including those of Marie Fox, a painter whose subject matter combines western (colonial) techniques and styles with expressive ancestral mythologies and mysticism that have contemporary resonance (p. 61).

The richly associative pictorial essays that comprise Carol Collicutt's *In the Garden* (pp. 36-37) similarly deal with the passage of generations and the interaction of past and present. Collicutt's work references a methodical family history research project. It is a work of reimagination, imagistic storytelling that is more associative than linear as the artist has cast herself as both artist and subject.

Can we ever completely understand another person or indeed our own selves? This simple yet fathomless question has inspired Suzanne Hill across an artistic career characterized by a constant experimentation with the ways figurative representation can expose heartfelt truths. Her dynamic drawings, sculptures, and installations encourage viewers to probe the inscrutable essence of a human soul, be it one's own or another's. Direct, immediate, and frequently visceral, Hill confronts us with the challenges of unknowability. More maps than figures, her artistic topographies are traced on carapaces, skins, and souls that both make things clear and indistinct at the same time, much like character itself where outward attitude may or may not accurately reflect the purpose of the heart (p. 53).

The difficulty of understanding ourselves is a theme that informs the work of I-Chun Jenkins (pp. 50-51). Her woven paper constructions point to the delicately nuanced interactions of the forces and challenges she has encountered in her life. Autobiographical, her art embraces dark and light to depict her personal journeys of immigration and the difficulties an immigrant encounters when seeking to integrate into a new society. She tells of the challenges of being a creative artist in New Brunswick, connected to a global marketplace yet grounded in the realities and challenges posed by the particularity of rural life.

Tracy Austin's sculpted wearable garments provoke conversations about clothing, fashion, and identity (p. 65). Austin's style embraces darkness as a motif and metaphor. She combines occult and gothic elements with devices signaling beauty and the ferocity of nature. Her sculpted objects reference traditional tailored garments such as corsets, jackets, and layered petal skirts. Austin's art counters the argument that fashion is frivolous and, additionally, is imbued with a spiritual dimension, reflecting her personal interest in the occult and unknown — perhaps esoteric — spiritual practices. Hers are empowering designs that embrace darkness as a means of emphasizing the power of femininity.

Teresa Marshall also examines how clothes function as emblems of tradition and power. Her multimedia sculptures and installation pieces address "the ellipses and absences in the dominant Eurocentric version of North American history" (p. 60). Her body of work, also comprising clothing embroidered with symbolic, traditional motifs from the Mi'kmaw nation, reflects her upbringing on a bicultural military reserve and the Millbrook First Nation. Her art reclaims her past, translating it into visual devices that testify to the ability to draw strength from pre-colonial history and ancestors. Marshall's work foregrounds voices and histories that have been silenced and expunged from western cultural memory.

[○]

The idea of art carrying the individual away via moods and emotions is entirely encapsulated in the elegantly carved and delicately sculpted paddles by Timothy "Bjorn" Jones and the wondrously allusive photographs of James Wilson. While Jones states that his subject matter is the past, his finished works of art, based on the simple engine of conveyance through water that is the paddle, trace a conversation with Indigenous traditions (p. 64). Wilson's photographs prompt an awareness that a watershed is a living organism: a delicate, fragile ecosystem that is dependent on all elements, both natural and human, to interact harmoniously (pp. 56-57).

Jones and Wilson both explore personal relationships to land and water and the means by which artists engage with tradition and present realities. In the shape and weight of his paddles, in the turn of line, and in the iconographies engraved on the wood, Jones transports the viewer to a vast, uncharted place that is both the immediate present as well as something eternal and deeply resonant. In a similar way, Wilson's *Minister's Face* calls to mind a deep personal history blended with the people and animals that came before us on this land beside the water.

Gina Etra Stick's elegant porcelain vessels also capture what it is to be alive and present (p. 62). Stick wishes to incarnate the "life force" in her work, seeking to give it a form. Physical objects with spiritual presence, Etra Stick's vessels compel us to be attuned to their resonant characters, to how they can lead the eye, mind, and consciousness to a state of being she calls "unfabricated awareness."

[o]

A walk through an art exhibition is not a passive, transient event, and try as we might, we are not disengaged from what we see in the gallery rooms, around us, or what we are immersed in as part of the viewing experience. Every encounter is shaped by the viewer whose mind, in considering what is before their eyes or interacting with their senses, is given license to roam about in the environment of the gallery.

This exhibition reflects a personal interaction with objects and ideas that came before me, and which I organized from a vast array of stimuli. In recognizing the flow and flux of artistic method, my attention and interest ranged from object to object until this selection of artworks provided a satisfying coalition of forms, meanings, and associations. These are all works of art that caught me, demanded my attention. Just as the underlying momentum of consciousness is active, selective, and infused with reflections, memories, and moods, a certain poetic impulse informed the process of selection and rendered it as a perceptual journey and as a personal odyssey.

Carol Collicutt (New Brunswick)
In the Garden, 2018

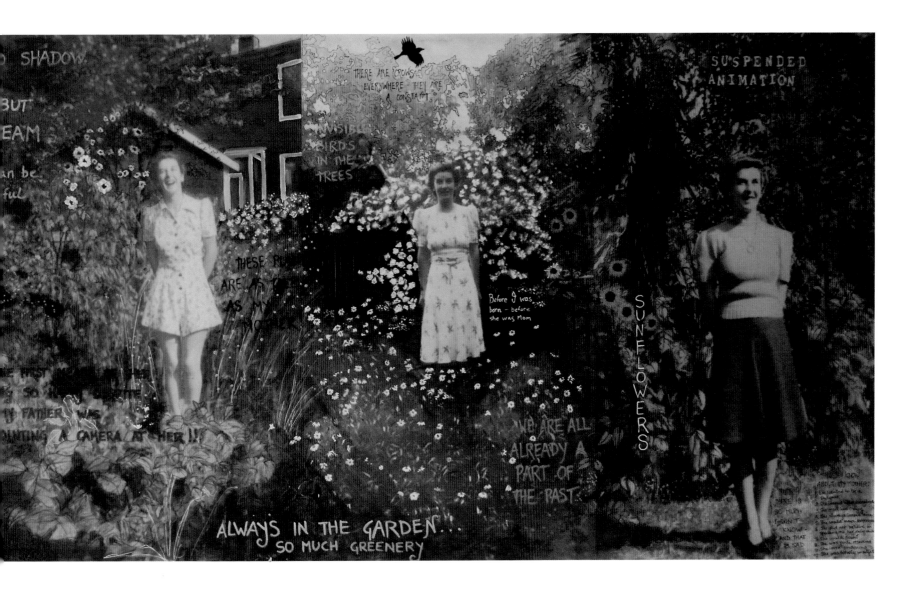

overleaf:

Stephen Hutchings (New Brunswick)

Now and Then, 2017

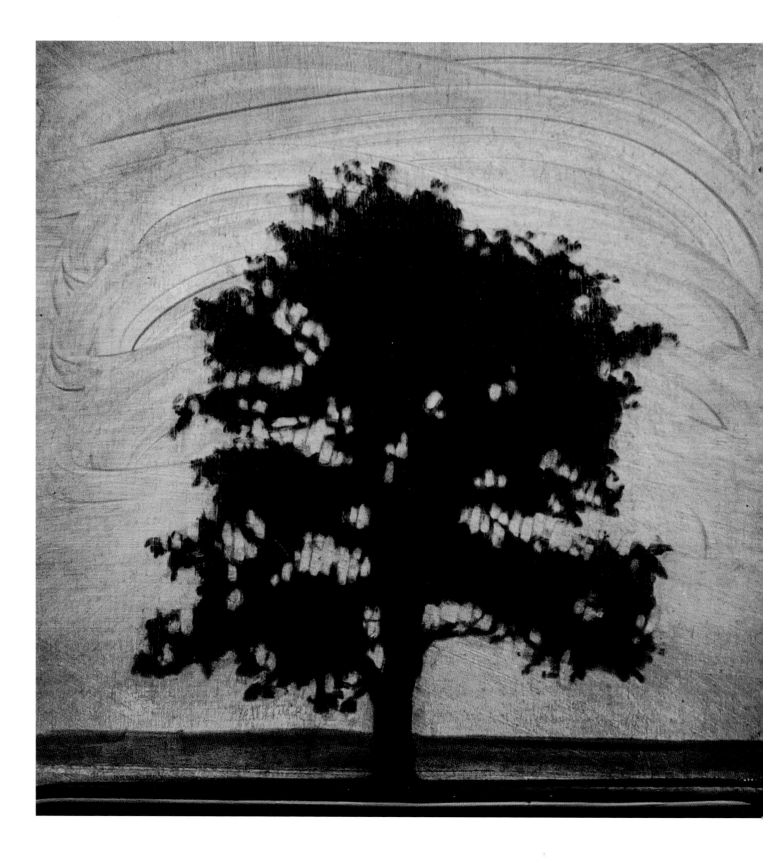

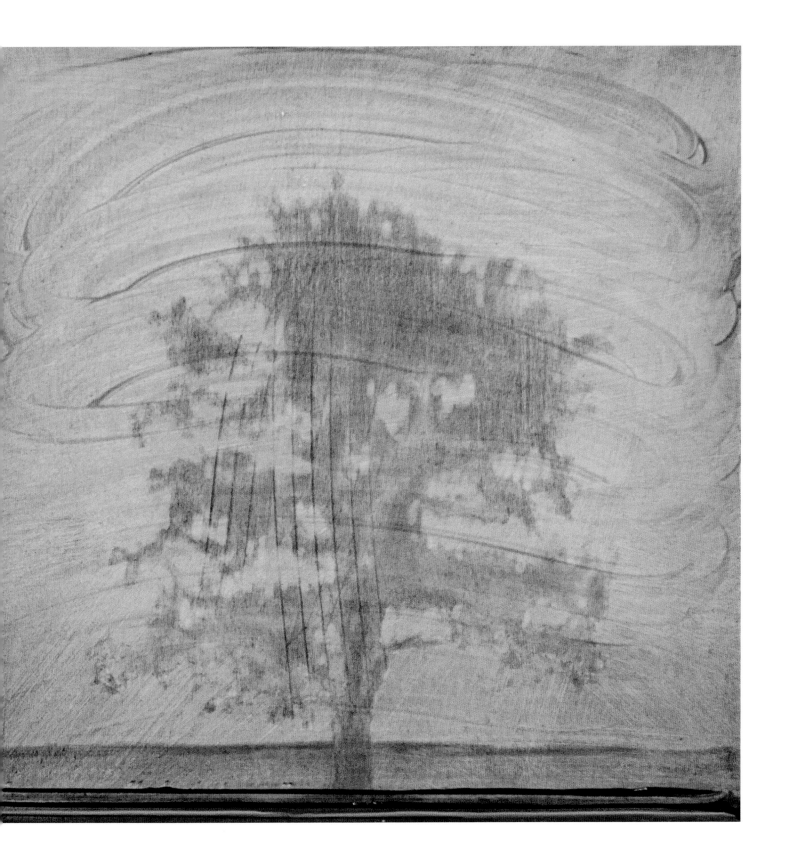

40 **Freeman Patterson** (New Brunswick)
Monet Willow / Un saule de Monet, 2017

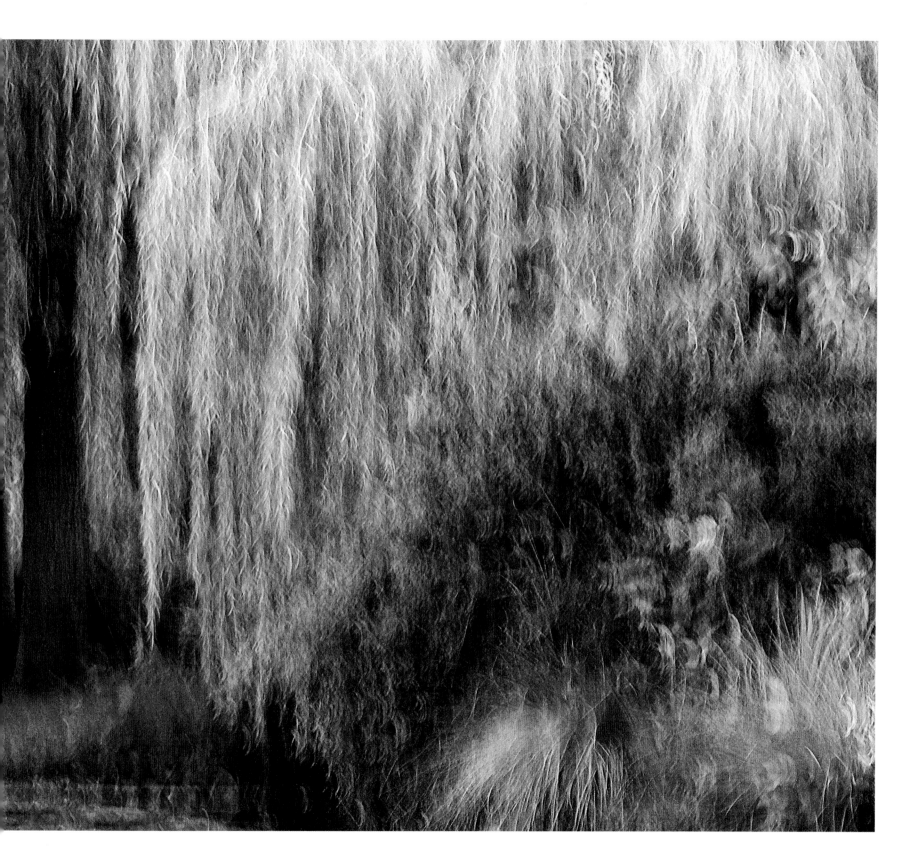

42 **David McKay** (New Brunswick)
Swaying with the Wind, 2019

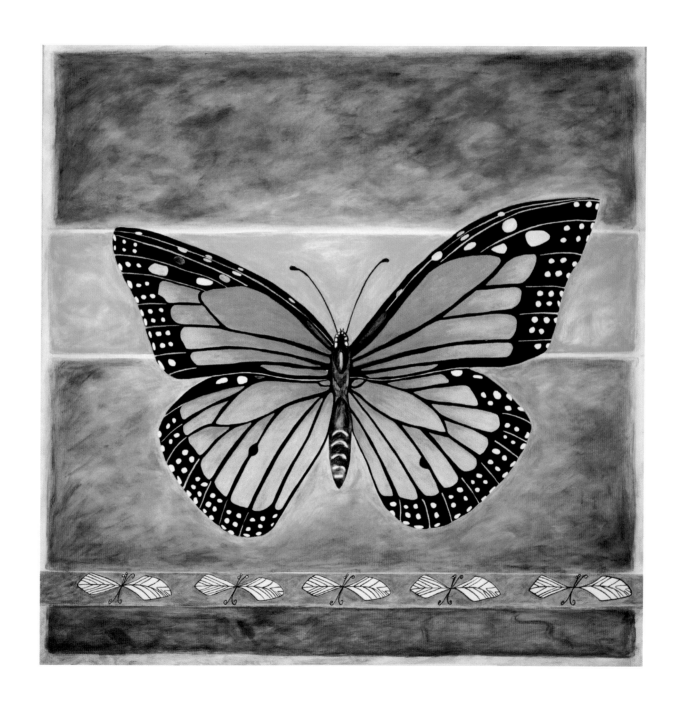

43 **Francine Francis** (Mi'kmaq/New Brunswick)
Mimikej – Monarch Butterfly – Papillon Monarque, 2018

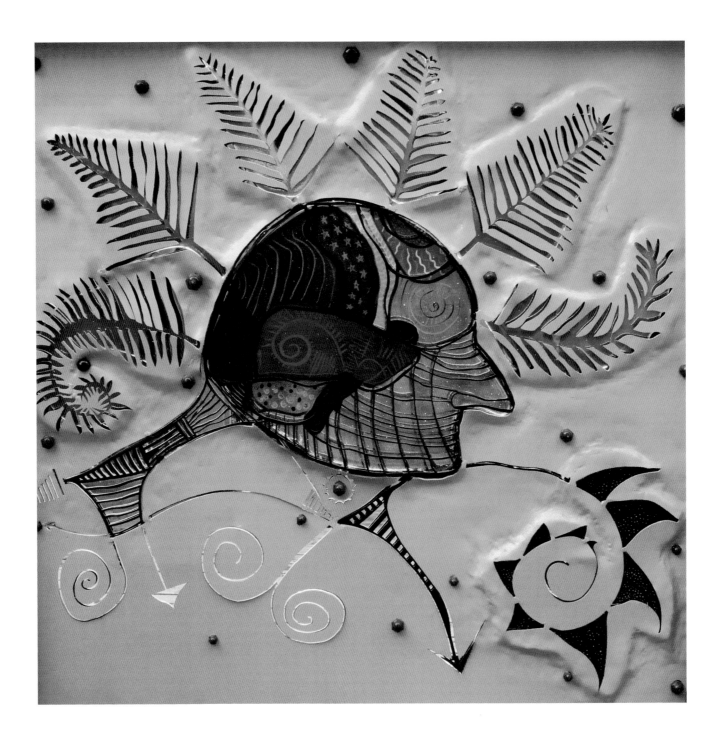

44 **Alan Syliboy** (Mi'kmaq/Nova Scotia)
Brain with Headdress, 2018

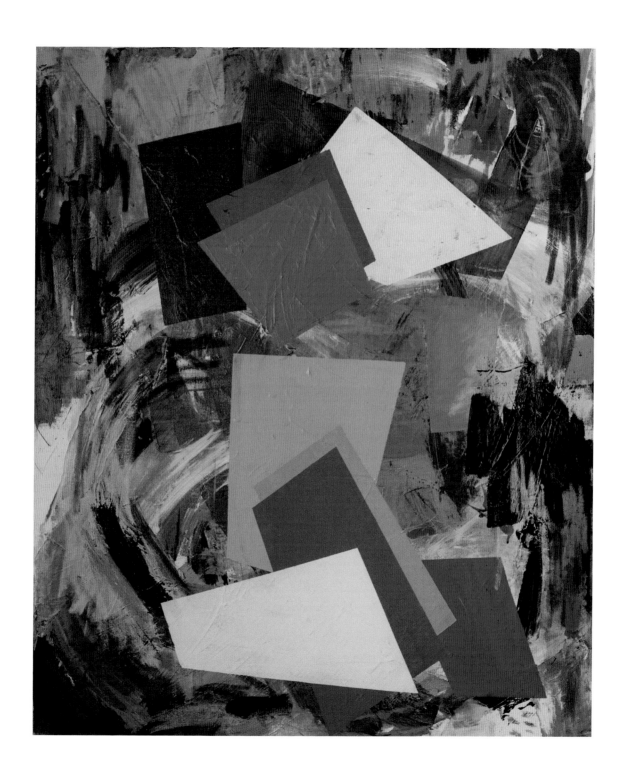

45 **Jared Betts** (New Brunswick)

81, 2012

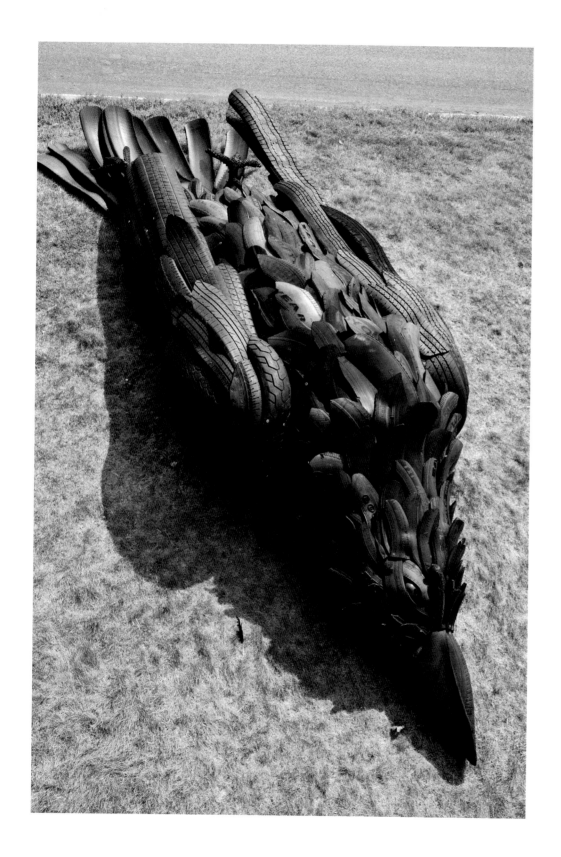

Gerald Beaulieu (Prince Edward Island)
When the Rubber Meets the Road, 2018
left: *Crow 1 (Cooper)*
opposite: *Crow 2 (Kelly)*

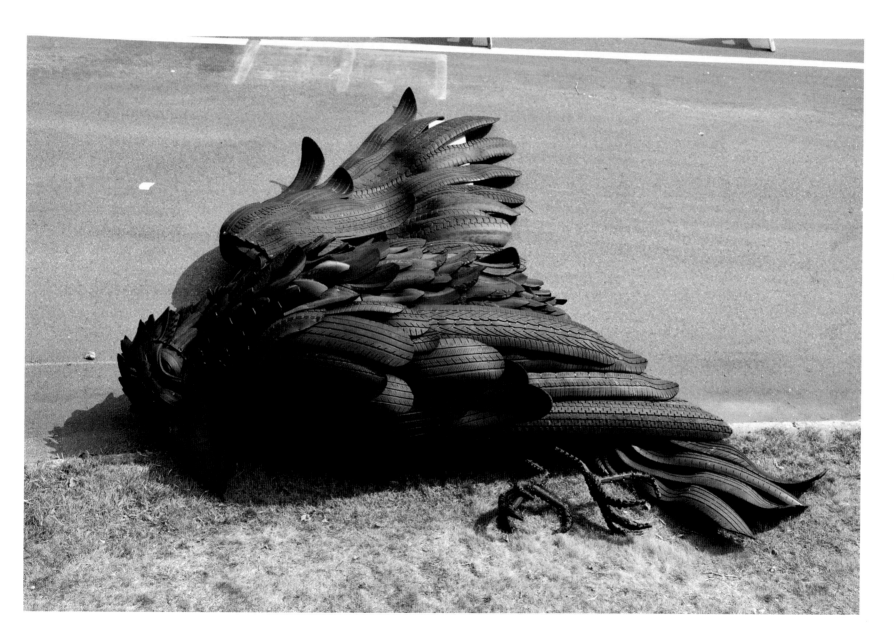

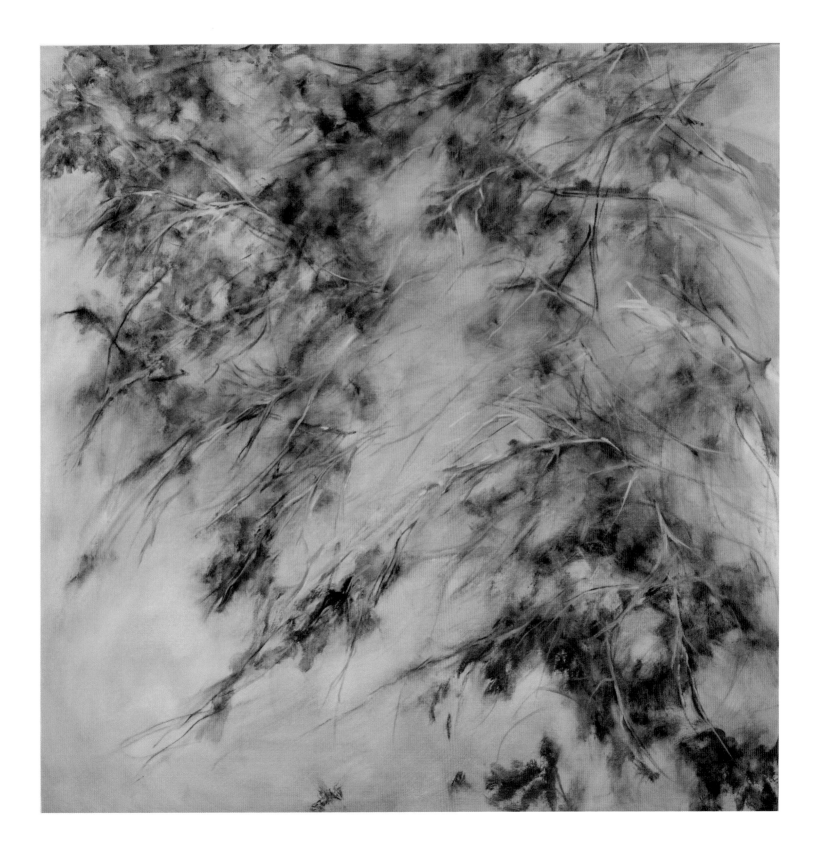

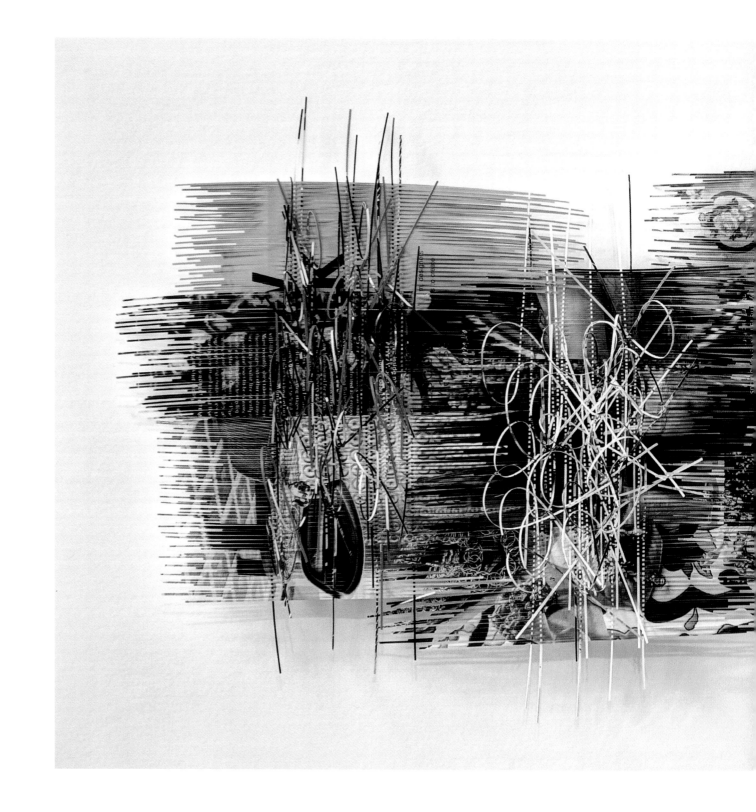

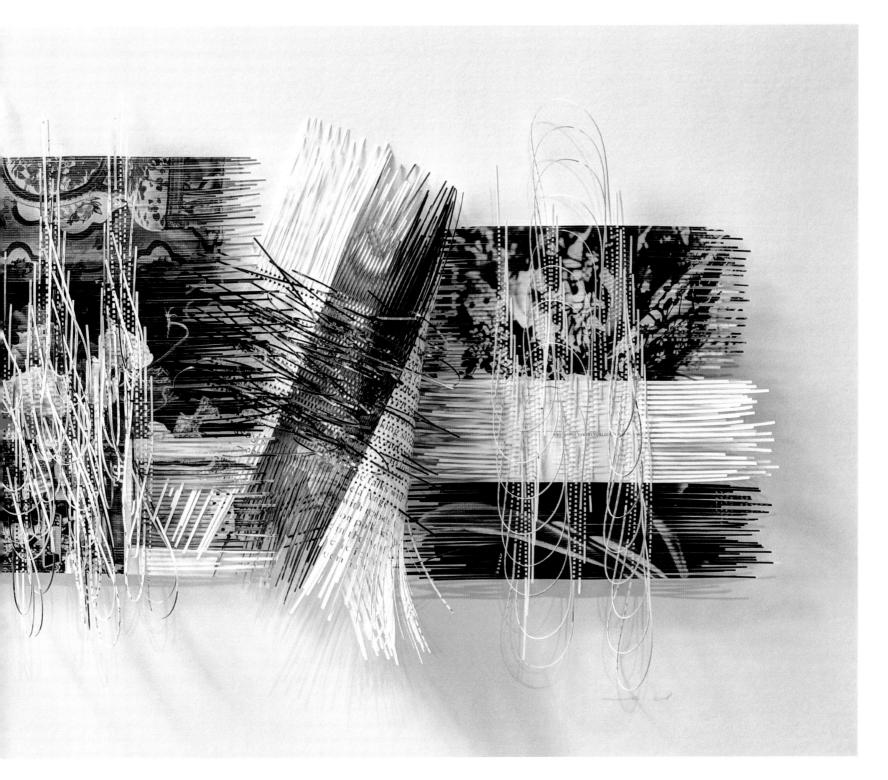

51 **I-Chun Jenkins** (New Brunswick)
Transcending Through Life, 2019

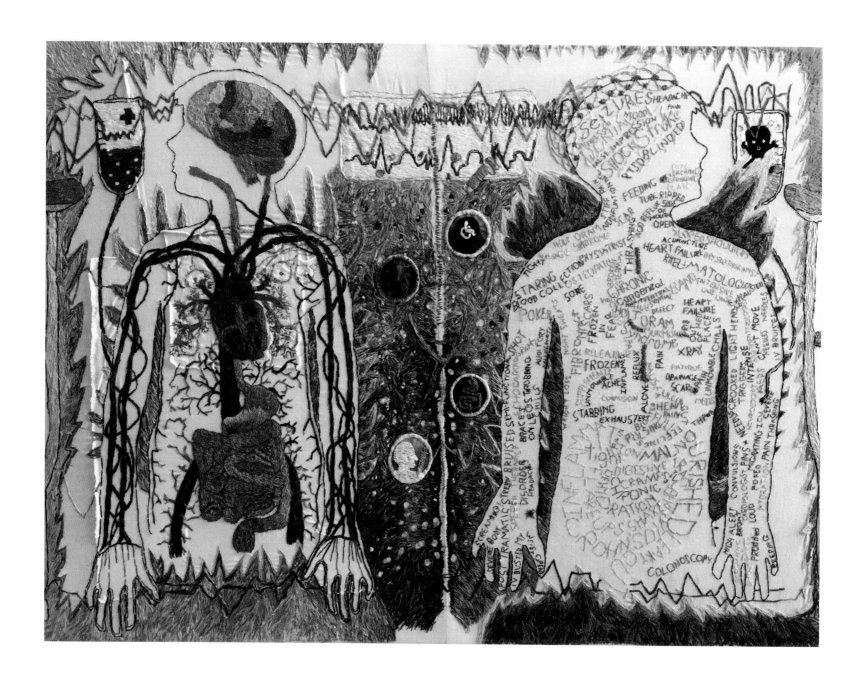

What the Mirror Doesn't See, Coping with Chronic Illness, Part 1—2014-2016, 2014-2016

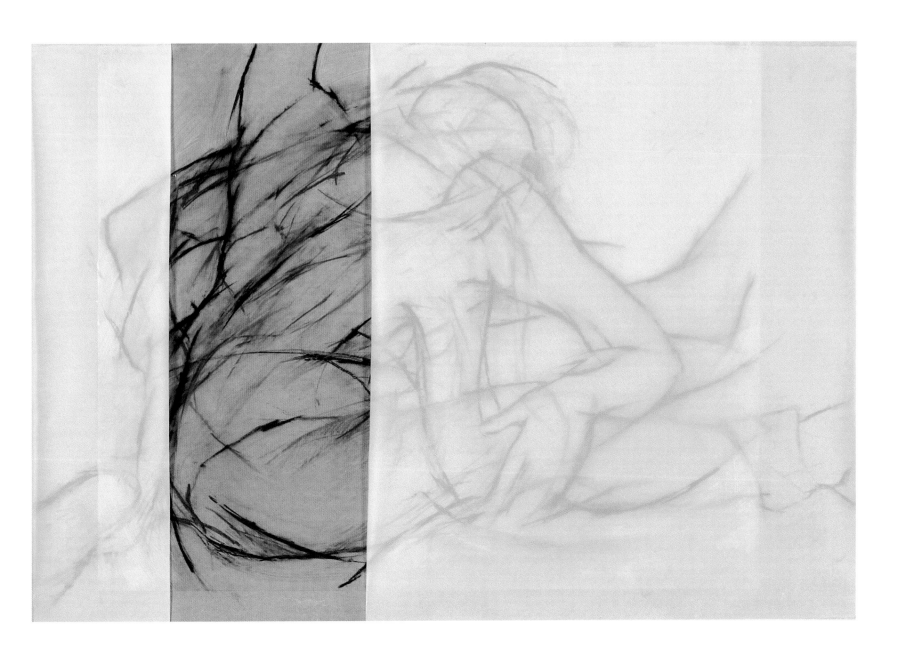

53 **Suzanne Hill** (New Brunswick)
Warm Up 3, 2018

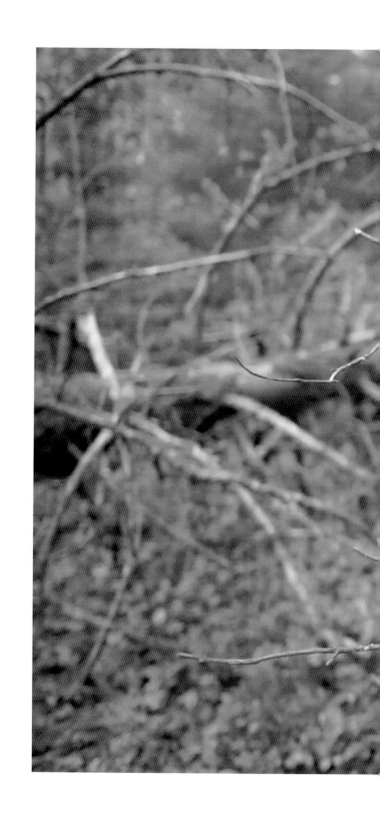

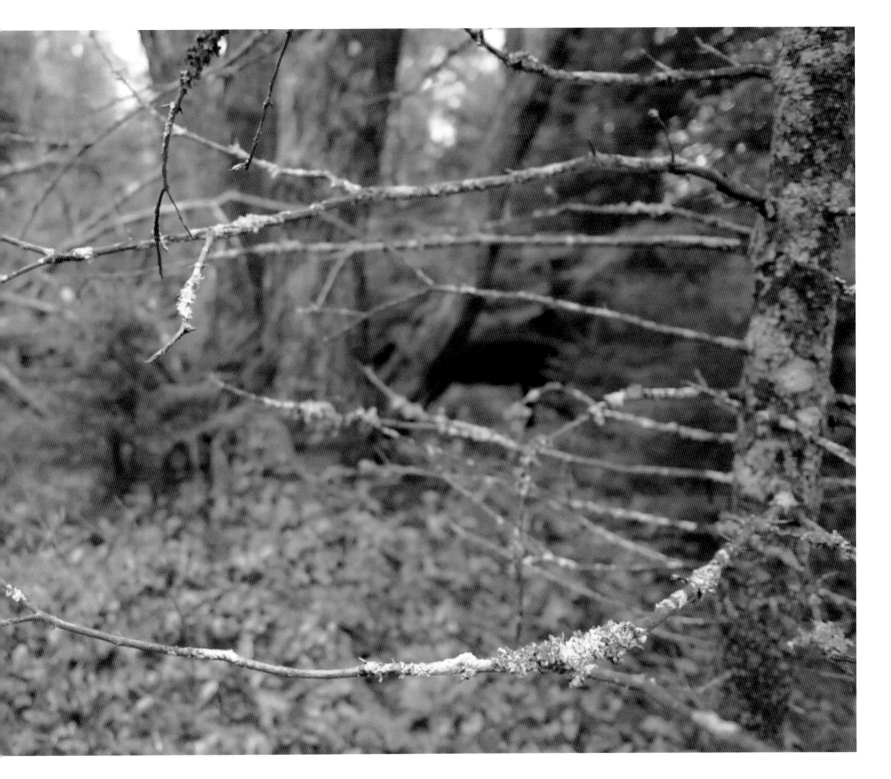

57 **James Wilson** (New Brunswick)

Minister's Face, Kennebecasis River, New Brunswick, 2014,

Kim and Wayne Brooks (Wolastoqiyik/New Brunswick)
Hat, 2018

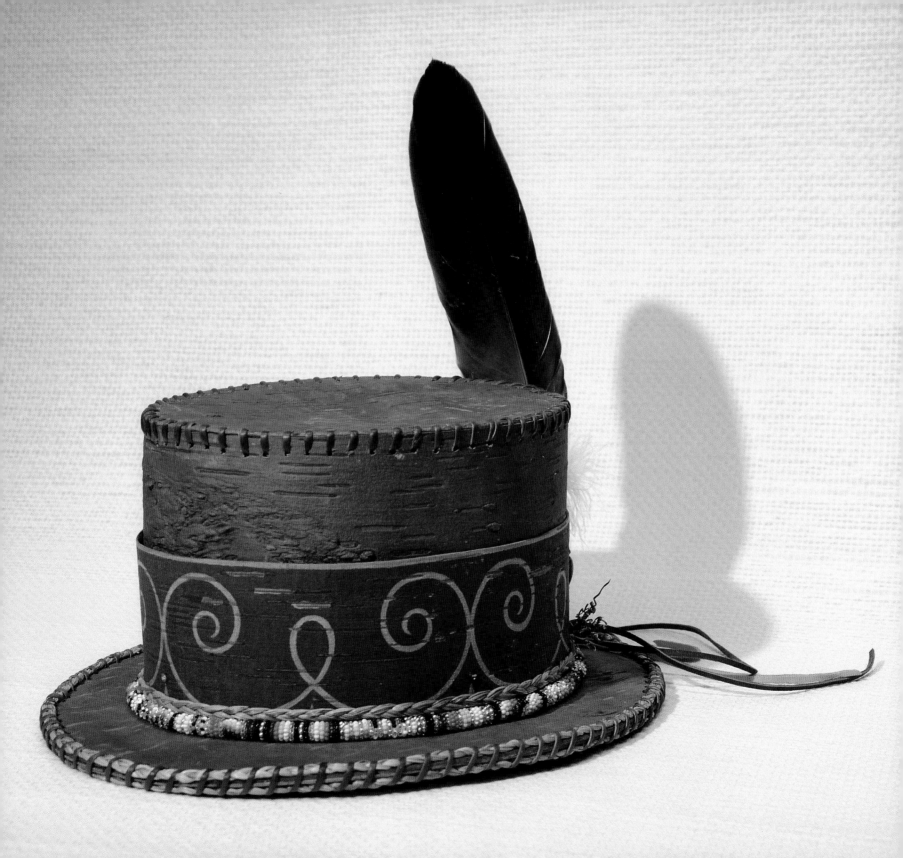

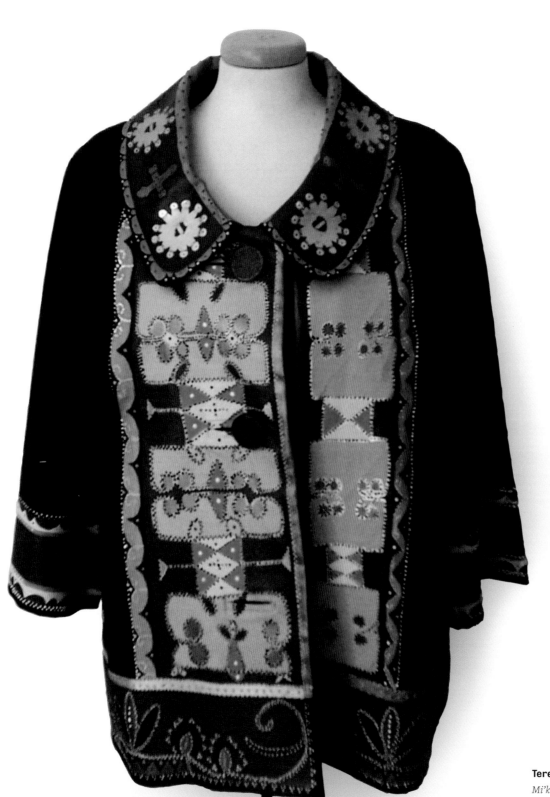

Teresa Marshall (Mi'kmaq/Nova Scotia)
Mi'kmaq Bolero Regalia, 2014

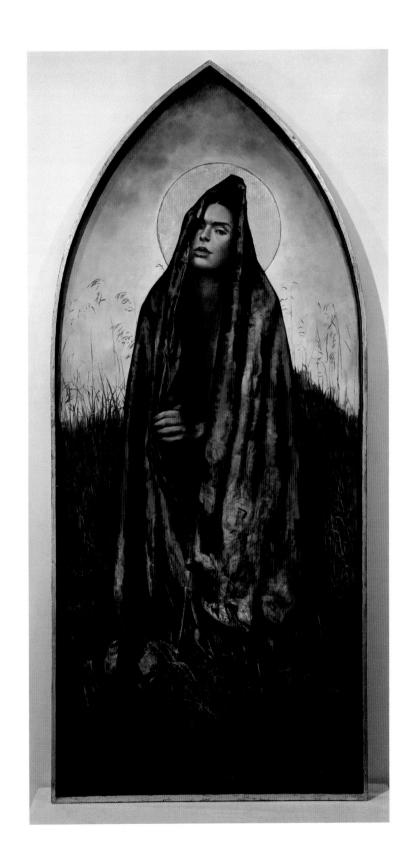

Marie Fox (New Brunswick) 61

Monument, 2018

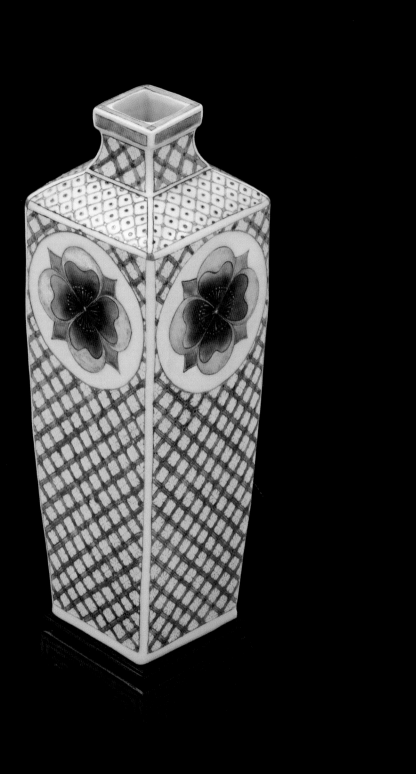

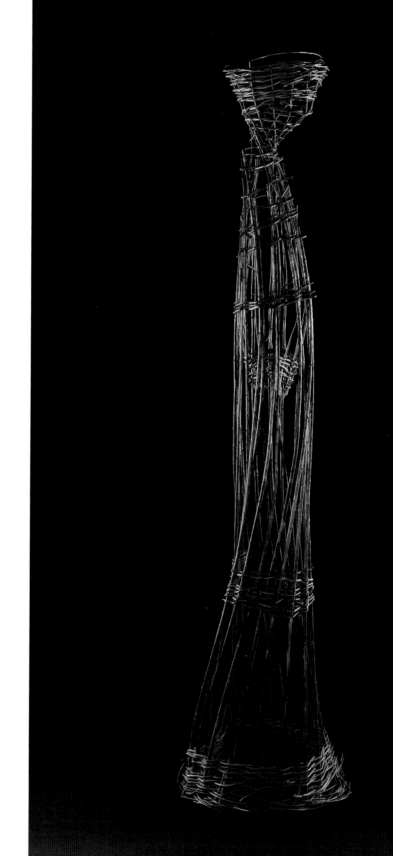

right:
Dawn MacNutt (Nova Scotia)
Soul Within, 2018

opposite:
Gina Etra Stick (Nova Scotia)　　63
Vase with Flower Medallions, 2017

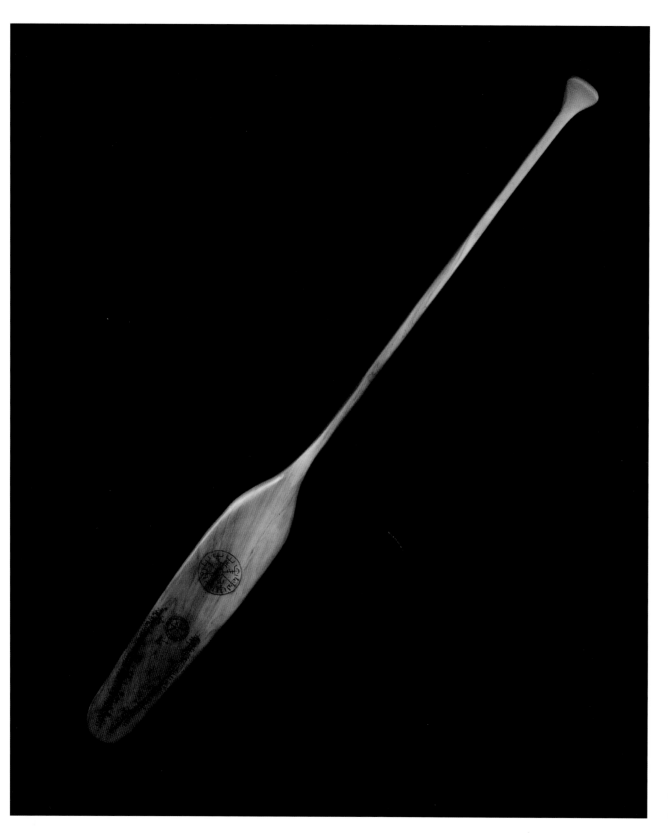

Timothy "Bjorn" Jones (New Brunswick)
Aeti, 2018

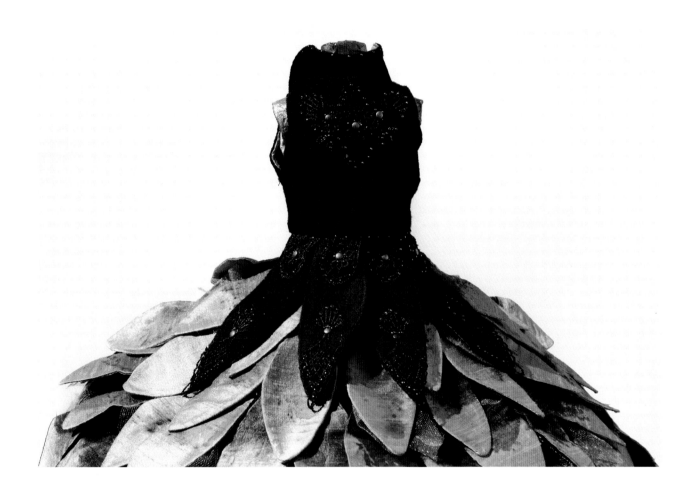

65 **Tracy Austin** (New Brunswick)
Auric, 2017

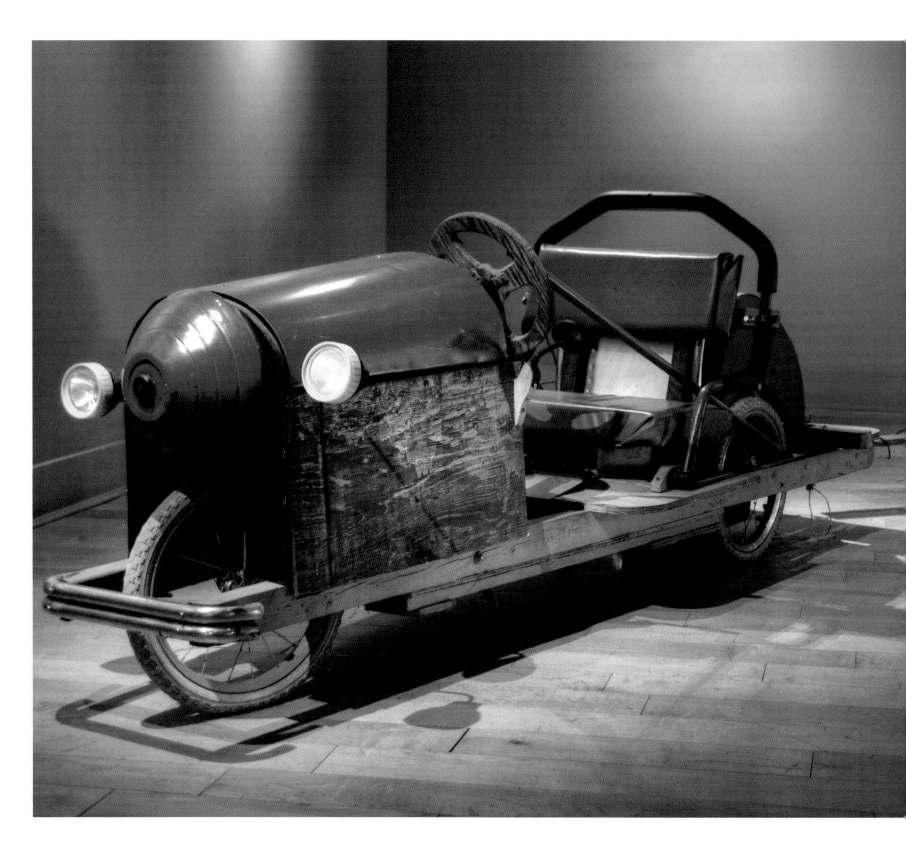

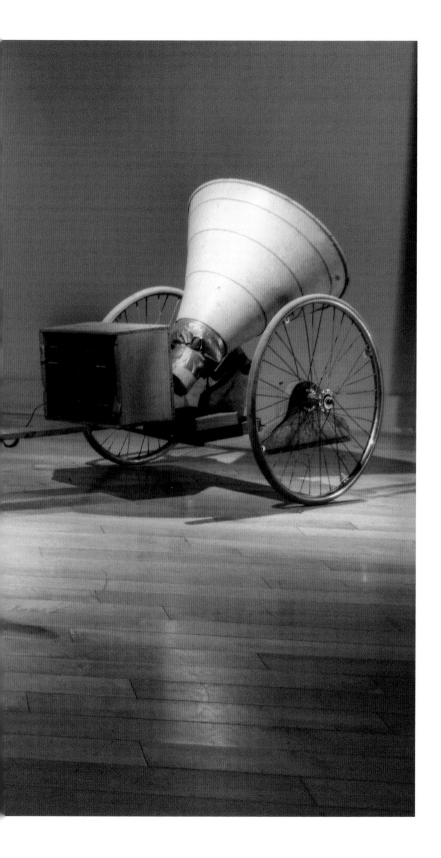

William Forrestall (New Brunswick)
The Red Bug and the Flyer (two vehicles), 2018

68	**Emma Hassencahl-Perley** (Wolastoqiyik/New Brunswick)

Creation Story II, 2018

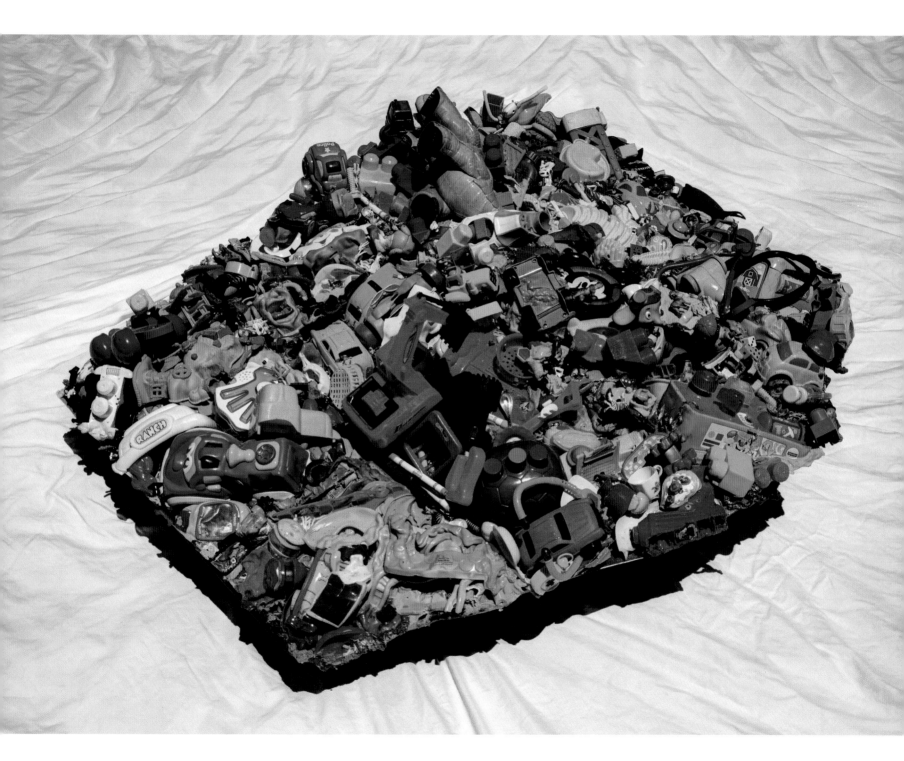

69 **Brian MacKinnon** (New Brunswick)
Merge, 2019

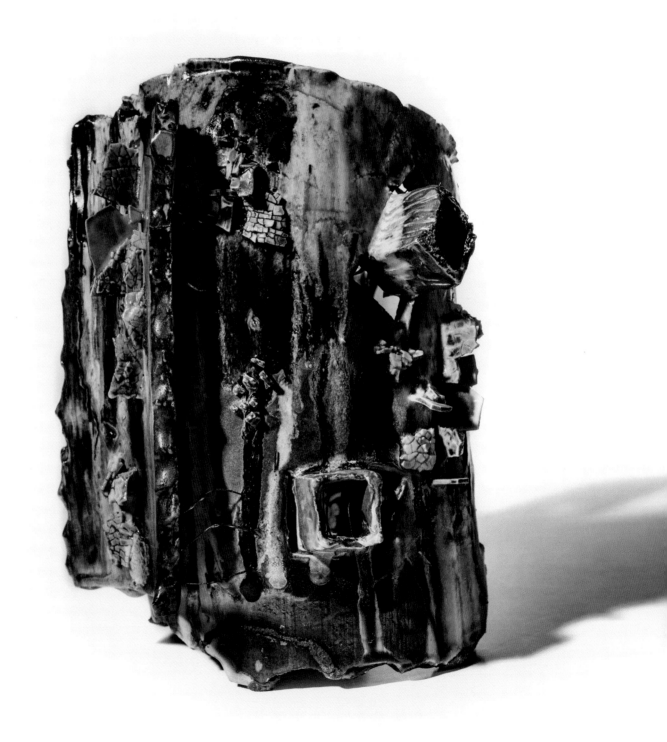

70 **Yalda Bozorg** (New Brunswick)
Not What it Seems, 2019

List of Works

Carrie Allison (Cree/Métis/Nova Scotia)
Beaded Botanical 1 (allium tricoccum), 2018
Toho beads on linen
30 x 42.5 cm
Collection of the artist

Katie Augustine (Wolastoqiyik/
New Brunswick)
Psihqiminsok (strawberries), 2019
white ash, sweetgrass, fabric dye
25.4 cm round
Collection of the artist

Tracy Austin (New Brunswick)
Auric, 2017
hand dyed silk dupioni, wool, lace, seed
beads, ribbon, eyelets, rigilene, and tulle
50 x 40 x 40 cm
Collection of the artist

Edward "Ned" Bear (Cree-Wolastoqiyik/
New Brunswick)
Napeh Kaso yinew Kiskeyitan, 2018
butternut wood and horse hair
40.6 x 55.9 cm
Collection of the artist

Gerald Beaulieu (Prince Edward Island)
When the Rubber Meets the Road, 2018
rubber tires
Crow 1 (Cooper) 487.7 x 121.9 x 182.9 cm,
Crow 2 (Kelly) 487.7 x 487.7 x 121.9 cm
Collection of the artist
The artist gratefully acknowledges the support
of the Canada Council for the Arts.

Jared Betts (New Brunswick)
81, 2012
mixed media on canvas
76.2 x 101.6 cm
Collection of the artist

Beth M. Biggs (New Brunswick)
Host(ess) Monarch, 2008
Sterling, copper, enamel, and pearl
15.5 x 9.5 cm
Courtesy of Gallery on Queen, collection of
the artist, photography by Roger Smith

Yalda Bozorg (New Brunswick)
Not What it Seems, 2019
clay and wire
variable dimensions
Collection of the artist

Kim and Wayne Brooks (Wolastoqiyik/
New Brunswick)
Hat, 2018
25.5 x 31 x 34 cm
birchbark, eagle feather, and mixed media
Collection of the Beaverbrook Art Gallery

Luc A. Charette (New Brunswick)
Abstraction 04:112017, 2017
acrylic on canvas
240 x 360 cm
Collection of the artist

Janice Wright Cheney (New Brunswick)
still from *The Lucivee*, 2019
mixed media and video
variable dimensions
Collection of the artist
Technical assistance: Tom Cheney &
Christina Thomson
The artist gratefully acknowledges the
support of the New Brunswick Arts Board.

Brigitte Clavette (New Brunswick)
Wasted – 1861 Grams Sterling Silver, 2017
sterling silver
66 x 27.9 x 15.2 cm
Collection of the artist

Carol Collicutt (New Brunswick)
In the Garden, 2018
mixed medium composite photograph
on paper
200 x 87 cm
Collection of the artist

Raven Davis (Anishinaabe/Nova Scotia)
Child's Play for Them, Murder for Us, 2017
pipe tobacco, wild rice, beans, cotton, wood,
MDF, acrylic
88.9 x 121.9 cm
Collection of the artist

William Forrestall (New Brunswick)
The Red Bug and the Flyer (two vehicles), 2018
mixed media
variable dimensions
Collection of the artist

Marie Fox (New Brunswick)
Monument, 2018
oil on panel
106.7 x 233.7 cm
Collection of the artist

Francine Francis (Mi'kmaq/New Brunswick)
*Mimikej – Monarch Butterfly – Papillon
Monarque*, 2018
acrylic on canvas
102 x 102 cm
Collection of the artist

Charles Gaffney (Wolastoqiyik/
New Brunswick)
Qsihkawk, 2018
butternut wood, leather, cattail grass,
Varathane
55.9 x 30.5 cm
Courtesy of Gallery on Queen, collection
of the artist

Emma Hassencahl-Perley (Wolastoqiyik/
New Brunswick)
Creation Story II, 2018
acrylic on canvas
91.4 x 152.4 cm
Collection of the artist

Suzanne Hill (New Brunswick)
Warm Up 3, 2018
charcoal, mylar, and acetate on brown paper
52 x 77.4 cm
Collection of the artist

Stephen Hutchings (New Brunswick)
Now and Then, 2017
oil and charcoal on canvas
40.6 x 81.2 cm
Courtesy of Galerie St. Laurent + Hill

I-Chun Jenkins (New Brunswick)
Transcending Through Life, 2019
recycled paper products
45.7 x 101.6 x 10.2 cm
Collection of the artist

Ursula Johnson (Mi'kmaq/Nova Scotia)
ITHA Shopping Network, 2017
video and mixed media installation
Variable dimensions
Collection of the artist

Timothy "Bjorn" Jones (New Brunswick)
Aeti, 2018
cedar, charcoal, and Varathane
149.9 x 22.9 x 5.1 cm
Collection of the artist

Vicky Lentz (New Brunswick)
Where the Trees Meet the Stars, 2018
aluminum bar, hot glue, glitter, sequins
152 x 122 cm
Collection of the artist

Brian MacKinnon (New Brunswick)
Merge, 2019
melted plastic on steel car door
121.9 x 91.4 x 15.2 cm
Collection of the artist

Dawn MacNutt (Nova Scotia)
Soul Within, 2018
twined willow, paint
190 x 50 x 40 cm
Collection of the artist, photography by
Bruce Murray/Visionfire

Ann Manuel (New Brunswick)
Weed Species, 2014
aluminum ladder, birch trees, steel plate
254 x 127 x 272 cm
Collection of the artist; prototype for "Weed
Species," New Brunswick Art Bank collection,
photography by Oliver Flecknell

Teresa Marshall (Mi'kmaq/Nova Scotia)
Mi'kmaq Bolero Regalia, 2014
mixed media and fabric
size 12-14
Collection of the artist

Alexandra McCurdy (Nova Scotia)
Black Box with Shells, 2018
porcelain
15 x 15 x 15 cm
Collection of the artist, photography by Steve
Farmer

David McKay (New Brunswick)
Swaying with the Wind, 2019
egg tempera on panel
45.8 x 116.8 cm
Collection of the artist

Margot Metcalfe (Nova Scotia)
Rock Formation, 2016
edition 3/10
archival image printed with water based ink
on Hahnemühle 100% cotton rag paper
30.4 x 45.7 cm
Collection of the artist

Deanna Musgrave (New Brunswick)
A Conversation with Emma Kunz, 2019
acrylic on canvas
119.4 cm tondo
Collection of the artist

Freeman Patterson (New Brunswick)
Monet Willow | Un saule de Monet, 2017
AP 1/2
photography (digital capture, ink jet print)
40.6 x 61 cm
Collection of the artist

Jennifer Pazienza (New Brunswick)
Sorella I, 2019
oil on canvas
75 x 75 cm
Collection of the artist

Sarah Petite (New Brunswick)
Cosmo, 2018
encaustic on wood
83.8 x 83.8 cm
Collection of the artist

Laura Roy (Nova Scotia)
*What the Mirror Doesn't See, Coping with
Chronic Illness, Part 1 – 2014-2016*, 2014-2016
cotton floss on stretched unbleached cotton
96.5 x 71.1 cm
Collection of the artist

Jennifer Stead (New Brunswick)
A Forest, 2015
charcoal on Stonehenge paper
127 x 127 cm
Collection of the artist

Gina Etra Stick (Nova Scotia)
Vase with Flower Medallions, 2017
press-molded Jingdezhen porcelain, gucai
overglaze, 24k Roman and German gold
37 x 10 x 10 cm
Collection of the artist, photography by
Marvin Moore

Alan Syliboy (Mi'kmaq/Nova Scotia)
Brain with Headdress, 2018
steel, glass, acrylic, and birch
121.9 x 121.9 cm
Collection of the artist

James Wilson (New Brunswick)
*Minister's Face, Kennebecasis River,
New Brunswick*, 2014,
photographic print on archival paper
71 x 152.5 cm
Collection of the artist

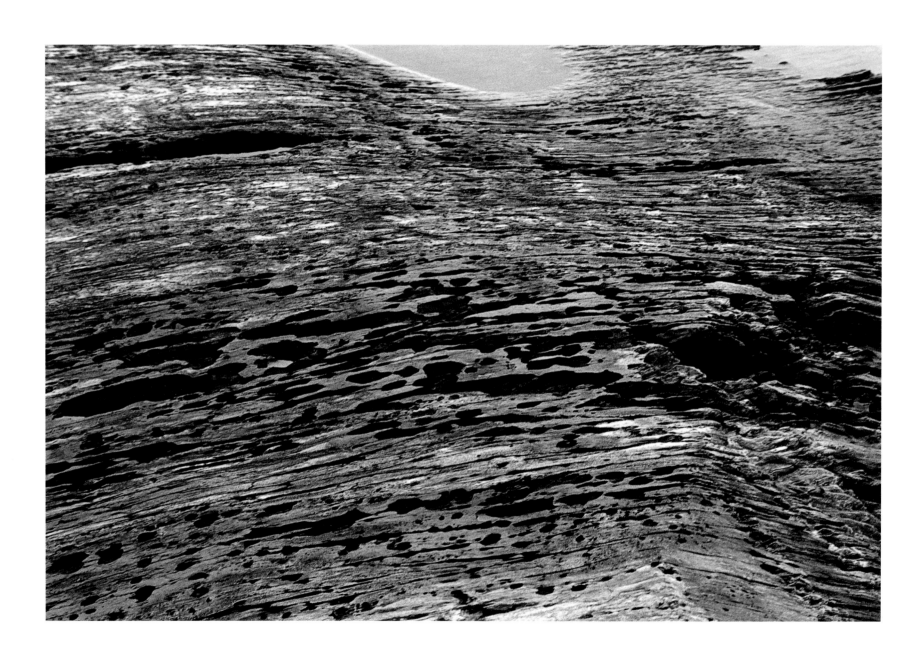

74 **Margot Metcalfe** (Nova Scotia)
Rock Formation, 2016

Artist biographies

CELINE GORHAM

Cree-Métis artist **Carrie Allison** is a graduate of NSCAD University in Halifax. Originally from Vancouver, BC, Carrie lives and works in K'jipuktuk (Halifax). Her master's degree exhibition, The Shubenacadie River Beading Project (2018), incorporated community-based artmaking and activism with traditional indigenous beadwork. She has two solo projects slated for 2019 in Nova Scotia and Alberta.

Artist and member of the Tobique First Nation, **Katie Augustine** earned a Diploma in Aboriginal Visual Arts from NBCCD and is the current acting Indigenous Recruitment Officer at NBCC. Katie is the owner of Negootkew Studio and is a member of the Mawi'art Collective.

Fredericton-based textile artist **Tracy Austin** received her Diploma in Fashion Design from NBCCD. She creates miniature textile garment sculptures with gothic and occult themes for ball-jointed dolls. She received a 2018 creation grant from artsnb to for her upcoming body of work, Weight of Power.

Plains Cree-Wolastoqiyik artist, curator, teacher, and community advocate **Edward "Ned" Bear** is based in St. Mary's First Nation in New Brunswick. His carvings are in the collection of the Beaverbrook Art Gallery and the NB Art Bank. In 2012, he was the focus of a solo exhibition at the Art Gallery of Nova Scotia. He is currently pursuing an MA in Native art education at UNB. Ned's work is in the permanent collection of the Beaverbrook Art Gallery.

Mixed media artist and arts advocate **Gerald Beaulieu** of PEI received his BFA from OCAD in 1987. He is the recipient of many creation and research grants from the government of PEI and the Canada Council

for the Arts. He has participated in many exhibitions and public art projects throughout Canada. His latest solo exhibition, *When the Rubber Meets the Road* (2018), received national attention from the CBC. Gerald's works are in the permanent collections of the Art Gallery of Nova Scotia, the Beaverbrook Art Gallery, and the Confederation Centre Art Gallery in PEI.

Jared Betts received his BFA from NSCAD University and currently works in Moncton. He has exhibited internationally and received a 2018 creation grant from artsnb and was awarded project funding from New Brunswick Tourism, Culture, and Heritage for a public art project for École Le Marais-Antonine Maillet. Jared's work is in the permanent collection of the NB Art Bank.

Artist and educator **Beth Biggs** received a BFA and BA in education from NSCAD University and an MA in Fine Arts from the State University of New York at New Platz. She was elected to the Royal Canadian Academy of Arts in 2006 and is the artist behind the design and metalsmithing of the Clarkson Cup for women's hockey. Beth's work is in the collections of the Nova Scotia Art Bank, Her Majesty the Queen of England, the Prince of Wales and the Duchess of Cornwall, Nunavut Arctic College, the MacDonald Arts Centre, and the Nunatta Sunakkutaangit Museum.

Based in New Brunswick, ceramic artist **Yalda Bozorg** received a BAA from UNB, a Diploma in Ceramics from NBCCD, and an MFA from Cardiff School of Art in the UK. She was an artist in residence at the Beaverbrook Art Gallery in 2018 and received both a creation grant and an artist in residence grant from artsnb that same year.

Kim and Wayne Brooks are Wolastoqiyik artists and craftspeople from the St. Mary's First Nation. They work in the traditional Wabanaki material of birchbark as a medium for everything from canoes to regalia and decorative vessels. They played a crucial role in the recent repatriation from Ireland of the Grandfather Akwiten canoe to the Wolastoqey people.

Mixed media artist and arts advocate **Carol Collicutt** holds a diploma from NSCAD University, a BA from Dalhousie University, and a BEd from St. Thomas University. A multifaceted artist who has worked in many media, she was one of the original artists involved in the formation of Fredericton's Gallery Connexion. She is the current chair of artsnb and her works are found in the permanent collections of the New Brunswick Art Bank, the Government of Canada, and the University of Moncton at Edmundston.

Artist and arts advocate **Luc A. Charette** holds an MA with Distinction (Visual Arts Media) from the School of Visual Arts at Laval University. His work is in the collections of the Beaverbrook Art Gallery, the NB Art Bank, and the Galerie Louise-et-Rueben-Cohen at the Université de Moncton.

Mixed media artist **Janice Wright Cheney** earned a BFA from Mount Allison University and a MEd in Critical Studies from UNB. She was inducted into the Royal Academy of Arts in 2010, won the Lieutenant Governor's Award for High Achievement in the Visual Arts in 2013, and the Strathbutler Award in 2004. Janice is an instructor at NBCCD.

Artist, metalsmith, and educator **Brigitte Clavette** was instructor and head of the metal department at NBCCD for over twenty years. She is the 2006 recipient of the Strathbutler Award and was elected to the Royal Academy of Arts in 2000. Her metal works are in the collection of such major institutions as the V&A in London and the ROM in Toronto.

Multimedia Indigenous artist, activist, and curator **Raven Davis** of the Anishinaabe (Ojibway) Nation is based in Toronto and Halifax. They are the director of communications for the Aboriginal Curatorial Collective and their work is on display in the exhibition *niigaanikwewag* at the Art Gallery of Mississauga.

William Forrestall is an artist, writer, curator, and part time professor in the Fine Arts department at STU. William is a member of the International Association of Art Critics and his works are in the collection of the Beaverbrook Art Gallery. A nationally recognized artist, he has an extensive exhibition record of over 150 solo and group exhibitions.

Painter **Marie Fox**'s work was presented at SOFA 2018, and she is currently represented by Gallery on Queen and Studio 21. In 2016, Fox was recognized as one of the Studio Watch: Emerging Artists at the Beaverbrook Art Gallery. More recently, Marie received an artsnb creation grant for her upcoming body of work titled "Celestial Bodies."

Mi'kmaw mixed media artist **Francine Francis** holds a BA in Indian fine arts from the First Nations University of Canada. She has exhibited throughout Atlantic Canada and is in the collection of the Beaverbrook Art Gallery and the NB Arts Bank.

Wolastoqiyik artist and educator **Charles Gaffney** holds a BA and MA in education from UNB and a BA in arts from STU. Charles's work was shown at SOFA 2018 and he has completed carved wooden masks for former prime minister Paul Martin and wooden paddles for Prime Minister Justin Trudeau. He is the Indigenous program lead and community engagement officer at NBCCD.

Wolastoqiyik artist **Emma Hassencahl-Perley** earned a BFA from Mount Allison University in 2017. She is the current emerging curator of Indigenous art at the Beaverbook Art Gallery and an instructor at the Aboriginal Visual Arts program at NBCCD.

Suzanne Hill was awarded the Lieutenant Governor's Award for High Achievement in the Visual Arts in 2016 and the Strathbutler Award in 1999. A former art teacher in the public school system, she has exhibited extensively. Her work has been acquired by numerous collectors and institutions, including The Canadian War Museum, the Canada Council Art Bank, the Beaverbrook Art Gallery and the Department of External Affairs.

A recent newcomer to New Brunswick, visual artist **Stephen Hutchings** has exhibited extensively across Canada. His work has been presented in major solo exhibitions at the Glenbow Museum in Calgary and the Beaverbrook Art Gallery, and is found in the permanent collections of the Alberta Foundation for the Arts, the Nova Scotia Art Gallery, the Canada Council Art Bank, and other organizations and institutions across the country.

I-Chun Jenkins holds a Diploma in Textile Design from NBCCD. Her woven paper sculptures were exhibited at SOFA Chicago (2018), the same year she won the Nel Oudemans Award. I-Chun will be exhibiting at Artplex Gallery (CA, USA) in 2019.

Multidisciplinary Mi'kmaw artist, curator, and educator **Ursula Johnson** holds a BFA from NSCAD University. She won the Sobey Art Award in 2017 and her ongoing installation, Mi'kwite'tmn, has been shown across Canada since 2014. Ursula is based in Eskasoni Nation, Nova Scotia.

Timothy "Bjorn" Jones is a wood carver and recent graduate of the NBCCD Aboriginal Visual Arts program. He is one of 11 artists-in-residence selected by the City of Fredericton for the upcoming summer residency in Odell Park, August 2019. Timothy will be creating works inspired by his Nordic heritage.

Edmundston, New Brunswick-based **Vicky Lentz** is a multimedia artist and educator. She served on the Premier's Status of the Artist task force, the board of the Sheila Hugh MacKay Foundation, and has organized and participated in a number of touring exhibitions of Acadian art.

Brian MacKinnon is a physician based in Fredericton and an avid visual artist. He participated in the recent exhibition *Hot Pop Soup* at the Beaverbrook Art Gallery in 2012.

Nova Scotian artist, sculptor, and educator **Dawn MacNutt** was inducted into the Royal Academy of Arts in 2008. She was director of the Canadian Crafts Council, and is a member of the International Sculpture Centre, the Nova Scotia Designer Craftsmen, and Visual Arts Nova Scotia. Her works are in major Canadian collections.

Award-winning painter, printmaker, educator, and arts advocate **Ann Manuel** earned a BFA from Mount Allison University, a BEd from Queen's University, and an MA in visual arts education from the University of British Columbia. She has participated in many solo and group exhibitions in Canada and internationally.

Teresa Marshall is a bicultural Mi'kmaw artist and advocate from Millbrook First Nation, Nova Scotia. She earned a BFA at Dalhousie University and NSCAD University. Her exhibition *Red Rising Hoods* was displayed at the Cape Breton University Art Gallery and received national attention from CBC.

Alexandra McCurdy holds a BFA from NSCAD University and an MA in 3D Design (Ceramics) from the Cardiff Institute of Higher Learning in Wales. She was inducted into the Royal Academy of Arts in 2015. In 2019, she will be participating in the 10th Gyeonggi International Ceramic Biennale in Korea.

David McKay was inducted into the Royal Academy of Arts in 2006 and awarded the Senate 150 Anniversary Medal in 2018. A consummate master of painted detail, his works are in the collection of the Beaverbrook Art Gallery, the NB Museum, and the NB Art Bank. He sat on the Board of Directors of the Canada Council for the Arts.

Margot Metcalfe is a photographer based in Halifax. She has exhibited widely throughout Canada in group and solo exhibitions since 1993. Margot's works are in the permanent collection of the Art Gallery of Nova Scotia, the Art Bank of Nova Scotia, and the Canada Council Art Bank.

Painter **Deanna Musgrave** holds a BFA from Mount Allison University, a BEd from UNB, and an MA in Interdisciplinary Studies from UNB. She has executed several monumental public art works in New Brunswick, including Cloud at the Hans Klohn Commons at UNBSJ and Mirror at Carleton North High School.

Photographer and writer **Freeman Patterson** was awarded the Order of New Brunswick in 2013, the Order of Canada in 1985, and was inducted into the Royal Academy of Art in 1975. One of Canada's

most renowned photographers, Freeman travels the world teaching photography workshops in South Africa and France, when he is not working at his home in the Kingston peninsula.

Jennifer Pazienza is a painter and recently retired professor in the faculty of education at the University of New Brunswick. She has taught and exhibited internationally, with works presented at Spectrum Miami (2018) and in a group exhibition in Italy (2019). Her works are in private collections around the world.

Self-taught encaustic painter and arts advocate **Sarah Petite** is based in New Brunswick and Nova Scotia. Renowned for her encaustic works, she is a CARFAC director and in 2011 won the National Visual Arts Advocacy Award. Sarah's works are found in private collections throughout the country.

Artist **Laura Roy** earned a BFA in Interdisciplinary Studies and a Visual Arts Certificate in Design from NSCAD University. Laura runs Impressions Letterpress, a paper goods company in Halifax. Her solo exhibition at the Andrew and Laura McCain Art Gallery, *What the Mirror Doesn't See*, appeared in spring 2019.

Artist and educator **Jennifer Stead** earned a BFA from NSCAD University, a Diploma in Art Education from McGill University, and an MFA from the University of Calgary. She is the executive director and curator at the Andrew and Laura McCain Art Gallery and has exhibited and taught across Canada. Her public art sculpture will adorn the Parliament Hill LRT stop in Ottawa.

Ceramic artist **Gina Etra Stick** earned a BA in Ceramics from NSCAD University, a BFA from the University of Chicago, and an MA in Architecture from the University of Washington. She studied traditional Chinese ceramic methods and decoration in Jingdezhen, China. Her work was presented at SOFA Chicago and FORM Miami in 2017. Her work is in the Gesan Palace Collection, Bhutan, and private collections around the world.

Alan Syliboy of Millbrook First Nation is an artist, musician, and activist. He was presented with the Queen's Golden Jubilee Medal in 2002 and was commissioned by the Canadian Mint in 1999 to create a limited-edition coin. He has work in the permanent collections of the Department of Indian and Northern Affairs, the Beaverbrook Art Gallery, the Owens Art Gallery, and the Art Gallery of Nova Scotia.

Photographer and educator **James Wilson** is based in Hampton, New Brunswick. One of eastern Canada's most highly-regarded portrait and landscape photographers, he was brought up in a photography family and was up until recently the holder of the Isaac Erb photography collection. James teaches acclaimed international photography workshops in Italy and Mexico.

Acknowledgements

The land on which the Beaverbrook Art Gallery is situated is the traditional unceded territory of the Wolastoqiyik and Mi'kmaq Peoples. This territory is covered by the *Treaties of Peace and Friendship*, which the Mi'kmaq and Wolastoqiyik first signed with the British Crown in 1726. The treaties did not deal with surrender of lands and resources but in fact recognized Wolastoqiyik and Mi'kmaq title and established rules for what was to be an ongoing relationship between nations.

I wish to express my gratitude to the H. Harrison McCain family for their generous support of this exhibition and for the many ways that they advance the art and artists of New Brunswick and Atlantic Canada.

I am grateful to Kim, Wayne, and Cody Brooks, Alan Syliboy, Charles Gaffney, Nadia Khoury, and Germaine Pataki for their advice and direction while researching this exhibition.

Thank you to the team at Goose Lane Editions who have worked with the Beaverbrook Art Gallery to produce this beautiful catalogue, in particular Julie Scriver and Alan Sheppard, and freelance editors Clarissa Hurley and Laura Kenins.

Finally, it has been a pleasure working with the Beaverbrook Art Gallery staff, particularly John Leroux and Celine Gorham, who endowed every aspect of this project with such professionalism and grace. My thanks goes out to Troy Haines, Mike Doucet, Sandra Nickerson, Julianne Richard, Jessica Spalding, Caine Harris, Kathryn Dimock, Anna Wyllie, Jeremy Elder-Jubelin, Meghan Callaghan, Shannon Harvey, Adda Mihailescu, Liliana Mitrovic, Christina Thomson, Aaron Fecteau, Roberte Melanson, Gerry Rhymes, Paula Murray, Kyle Kajari, Andrei Dragos, Jesse Gagné, Matthew Spence, Chris Crawford, Chris Larsson, Tim Murphy, James Kennedy, Tony Lewis, Patrick Doyle, Liam Fisher, Massimo Poirier, Elizabeth Bowden, Eliza Wolfe, Matthias Whalen, Valen Lapointe, Dori Szemok, Vivi Whalen, and Paige Parent.

Copyright © 2019 Beaverbrook Art Gallery.
Copyright in the individual works of art depicted herein belongs to the artists.

No part of this work may be reproduced or used in any form or by any means, electronic or mechanical, including photocopying, recording, or any retrieval system, without the prior written permission of the publisher.

Edited by Alan Sheppard and Clarissa Hurley.
French translation by Rachel Martinez.
Cover and page design by Julie Scriver, Goose Lane Editions.
Cover image: Deanna Musgrave, *A Conversation with Emma Kunz* (detail), 2019.
Printed in Canada by Friesens.
10 9 8 7 6 5 4 3 2 1

ISBN: 978-0-9813280-7-2

Published in conjunction with the exhibition *Materiality and Perception in Contemporary Atlantic Art* at the Beaverbrook Art Gallery from October 20, 2019 to January 26, 2020, curated by Tom Smart.

We acknowledge funding support of the Canada Council for the Arts and the Government of New Brunswick through the Department of Tourism, Heritage and Culture.

Canada Council Conseil des arts
for the Arts du Canada

New Nouveau
Brunswick
C A N A D A

Beaverbrook Art Gallery
703 Queen Street
Fredericton, NB
Canada E3B 1C4

beaverbrookartgallery.org

GALERIE D'ART
BEAVERBROOK
ART GALLERY